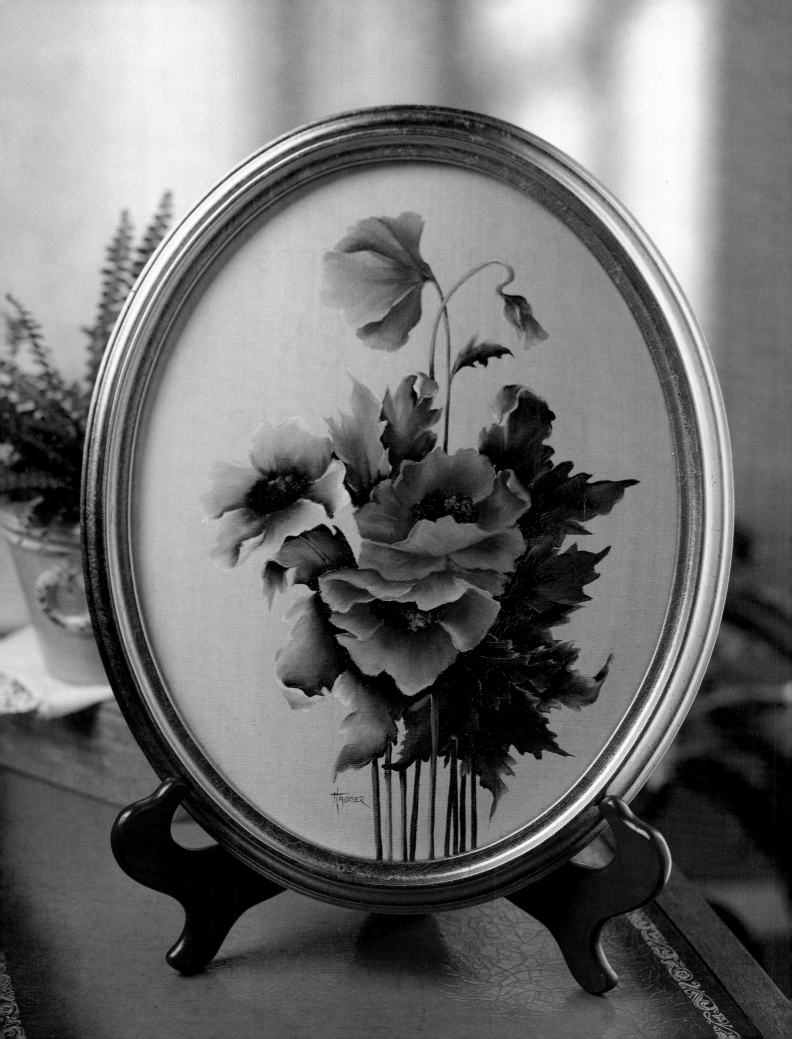

Priscilla Hauser's
FLOWER PORTRAITS

Priscilla Hauser

Sterling Publishing Co., Inc.
New York

Prolific Impressions Production Staff:
Editor in Chief: Mickey Baskett
Copy Editor: Phyllis Mueller
Graphics: Dianne Miller, Karen Turpin
Styling: Lenos Key
Photography: Jerry Mucklow
Administration: Jim Baskett

Library of Congress Cataloging-in-Publication Data Available

Hauser, Priscilla.
 Priscilla Hauser's flower portraits.
 p. cm.
 Includes index.
 ISBN 1-4027-0340-6
1. Painting--Technique. 2. Flowers in art. I. Title: Hauser's flower portraits. II Title: Flower portraits. III. Title.
 TT385.H39 2004
 745.7'23--dc22

 2004013446

Published by Sterling Publishing Co., Inc.
387 Park Avenue South, New York, N.Y. 10016

© 2004 by Prolific Impressions, Inc.
Produced by Prolific Impressions, Inc.
160 South Candler St., Decatur, GA 30030

Distributed in Canada by Sterling Publishing
c/o Canadian Manda Group, 165 Dufferin Street
Toronto, Ontario, Canada M6K 3H6

Distributed in Great Britain by Chrysalis Books Group PLC,
The Chrysalis Building, Bramley Road, London W10 6SP, England

Distributed in Australia by Capricorn Link (Australia) Pty. Ltd.
P.O. Box 704, Windsor, NSW 2756 Australia

Printed in the USA
All rights reserved
Sterling ISBN 1-4027-0340-6

About Priscilla Hauser

She has been called "first lady of decorative painting" because of her early involvement in the teaching of the craft and her key role in organizing the first meeting of the National Society of Tole and Decorative Painters on October 22, 1972. Since that first meeting, attended by Priscilla Hauser and 21 others, the organization has thrived, and so has Priscilla.

From her beginning efforts as a tole painter in the early 1960s, when she took classes at a YMCA in Raytown, Missouri, Priscilla Hauser has become a world-renowned teacher and author and the decorative painting industry's ambassador to the world. She has traveled to teach in Canada, Japan, Argentina, and The Netherlands and has instructed extensively throughout the United States and at her Studio by the Sea in Panama City Beach, Florida. Besides teaching, Priscilla has illustrated her techniques through books, magazine articles, videos, and television.

The results of her teaching program have led to an accreditation program for teachers.

Priscilla says to everyone, "I can teach you to paint. Come paint with me in my beautiful Studio by the Sea! You will learn the basics: brush strokes, double-loading, blending, and proper preparation of surfaces. You'll even learn some pen-and-ink techniques and some fabric painting." Priscilla's seminars are extremely valuable to beginners as well more advanced painters. Her methods teach the newcomer and strengthen the experienced. The seminars last five-and-a-half days and, after studying for 100 hours, you can become accredited with the Priscilla Hauser Program.

To receive seminar details, send for Priscilla Hauser's Seminar Brochure and Schedule, P.O. Box 521013, Tulsa, OK 75152-1013.

ACKNOWLEDGEMENTS

Inspiration comes from many places. Three things really inspire me: a) color; b) flowers (one of God's greatest gifts); and c) the wonderful people in my life who provide not only inspiration but give of their time and energies to make my work come alive.

Much appreciation goes to (alphabetically) Connie Deen, Judy Kimball, Naomi Meeks, Collette Ralston, Barbara Saunders, and Sue Sensintaffar. Without them, I would never have completed *Flower Portraits*.

Dedication

To my editor, Mickey Baskett and photographer, Jerry Mucklow. Their time, energy
and devotion were instrumental in the creation of this beautiful book.
Thank you, Mickey and Jerry.

CONTENTS

6

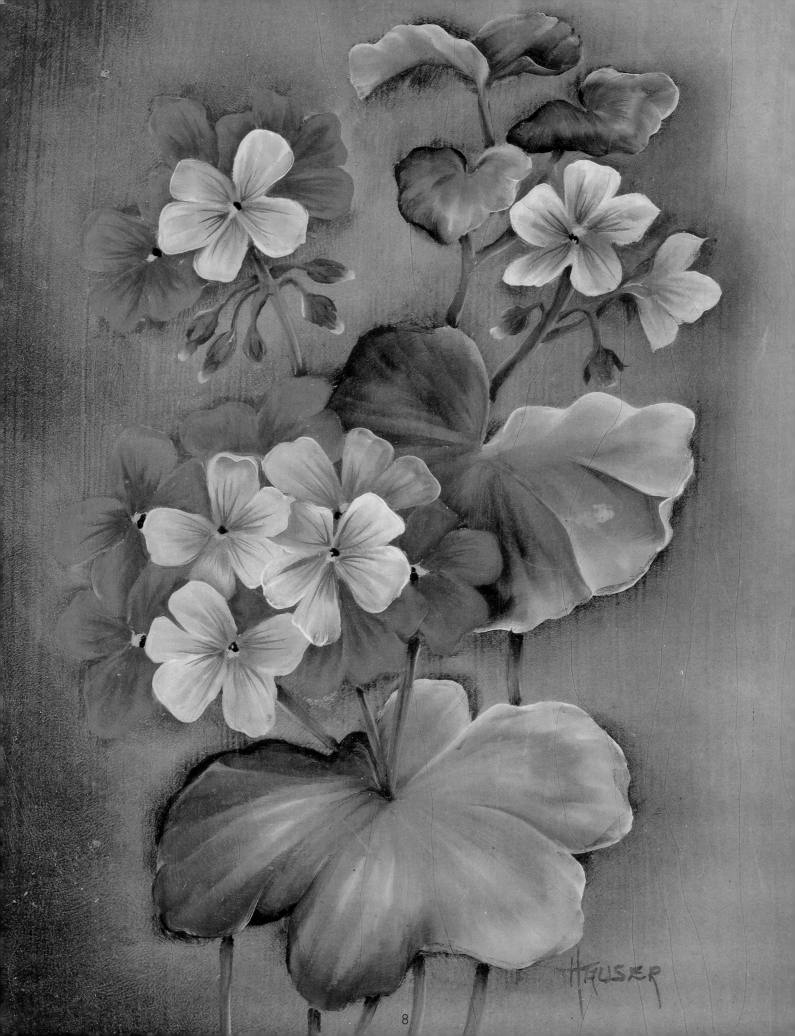

Introduction

This book features in-depth painting instructions for a variety of flowers. Each flower is used as a study, with step by step photos showing how each is painted, as well as painting worksheets that show each portion of the flower being painted in actual size. Like portraits, these projects are painted on canvas. Beautiful mottled backgrounds enhance the focus of each flower as it graces a framed piece of canvas.

When speaking of portrait painting, usually it refers to painting people. However, flowers are also a notable subject for painting a portrait. They are so beautiful, delicate, and one of God's great gifts to us. And, they hardly move at all for the portrait sitting.

According to *The American Heritage Dictionary,* flowers are "A plant that is cultivated or appreciated for its blossoms." But the word *flower* can also mean "The period of highest development; the peak." When we say someone has "bloomed" or "flowered" as an artist, we are paying them the ultimate compliment. So you see, my praise for the flower is not giving in to vain glory — they really are one of God's masterpieces — and worthy of a portrait.

I have chosen some of my favorite flowers for this painting study. I have also chosen flowers that I think you will enjoy painting because you will learn important skills for each flower. The skills you learn in the painting of each different flower can help you progress and allow you to move on to painting other subject matter. You can use these skills again and again. For example, the comma stroke you will use to paint daisy petals is the same comma stroke you will use to paint a wattle on a rooster.

In each flower painting lesson, you will not only have the advantage of seeing, in photo form, the flowers painted step by step; but also the *Painting Worksheets* for each flower are visual progressions of the painting skills you can master. Study these photos and worksheets for each flower — then practice, practice, practice. That is my mantra — practice, practice, practice. An easy way to practice each flower is to put a piece of stable plastic (such as acetate) or tracing paper on top of each of the worksheets, then paint directly on top of the worksheet, following my brush strokes. You can wipe the paint from the plastic and practice over and over until you feel comfortable with painting the flower.

Originally I did many of these flower portraits with oil paints. When I started teaching my painting technique, oils were all we had. Now, acrylic paints have improved so significantly that they are now the paint of choice for many decorative painters. Artist pigment acrylics now have the same true pigmented colors as oils, and with the use of painting mediums, they are very blendable. The instructions give the palettes for using acrylic paints, but these same palettes can be used if you prefer to use oil paints.

I hope you will enjoy painting these lovely gifts from nature.

Priscilla Hauser

DECORATIVE PAINTING SUPPLIES

Paints

*When painting flowers (or anything else, for that matter), the brilliance and illumination of color is extremely important. So, be selective when purchasing the paint to create your beautiful portraits. The worksheets and instructions in this book were created and designed with **artist pigment acrylics**, which are equivalent to **tube acrylics**. Some of the projects pictured were originally created with **oil paints**. The painting techniques for all three are very similar.*

Artist Pigment Acrylics & Tube Acrylics

Artist pigment acrylic paints come in squeeze bottles and are available at art supply and craft stores. Their pigment is brilliant, and you can blend them and move them much in the same way as oil paints by using painting mediums. Artist pigment acrylics and tube acrylics have true pigment color names, just like oil paints and the paints are true colors – they have no white or other colors mixed into them.

There is a big difference between **bottled acrylics** (which I endearingly call "craft paint") and fine artist pigment acrylics and tube acrylics. Most craft paint is similar to wall paint. Bottled acrylic craft paints are fine for basecoating (the first coat of paint that's applied before the design is transferred) and backgrounds.

You can choose to use oil paints instead of pigment acrylics. Keep some things in mind. When working with oil paints, one would not use an acrylic blending medium. Also, when using oils an undercoat is often not necessary. For the projects in this book, the choice is yours – paint with the medium you enjoy.

Mediums

Mediums are liquids or gels that are mixed with acrylic paint for achieving specific effects. They are sold along with artist pigment acrylic paints.

Floating Medium

This product is used to thin the paint so that it can be used for floating a color. The brush is filled with the floating medium, a corner of the brush is then filled with color. After the brush is blended on the palette, the color is brushed along the edge of a design element to create a shading or highlighting.

Blending Medium

Use this medium to keep the acrylic paint wet and moving. The medium is painted onto the surface before adding the paint colors to the surface that you wish to blend. The design is painted and colors blended immediately while the blending medium is still wet.

Glazing Medium

This medium is used to thin the paint so that the mixture can be used for flyspecking or antiquing. The glazing medium is mixed with paint on a palette or in a small container until a very thin, transparent consistency is reached. Glazing medium can also be used as a substitute for floating medium. It works in the same way.

Painting Surfaces

Canvas

Most of the flower portraits in this book are painted on canvas. Canvas can be purchased in a variety of shapes (I've used ovals and rectangles) that are pre-painted and ready for painting. I like to lightly sand the surface of the canvas, then wipe with a tack cloth before painting.

Pressed Fiberboard

Another surface I have used is pressed fiberboard, often called by the trade name, Masonite®. It can be cut to any shape with a saw, and the smooth surface is ready to paint.

Mat Board

In this book I've also included some pieces painted on mat board, which is available in a variety of colors and textures at art supply stores and frame shops. Mat board needs no preparation and can be cut to any shape with a craft knife or utility knife.

Brushes

Flat Brushes

Flat brushes are designed for brush strokes and blending. These brushes do most of the painting of the designs.

Round Brushes

Round brushes are used primarily for stroking – we seldom blend with them. They can also be used for some detail work.

Filbert Brushes

Filbert brushes are a cross between a flat and a round brush. They are generally used for stroking, but can also be used for blending.

Liner Brushes

Liner brushes are very thin round brushes that come to a wonderful point. Good liner brushes are needed for fine line work.

There are many different types of brushes available to the artist. Different-shaped brushes do different things. You will need the four types of brushes listed as follows in various sizes to do your decorative painting. The individual project instructions list the types and sizes of brushes needed for that particular project.

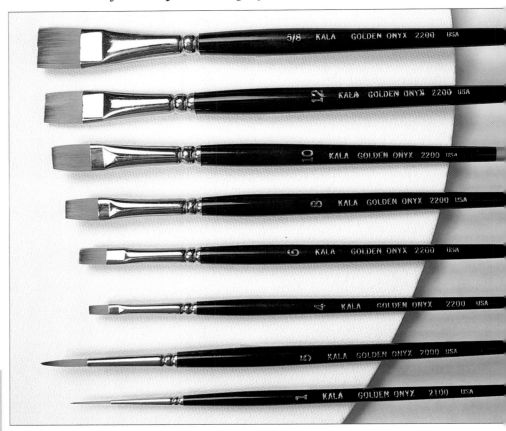

BRUSH CARE

It's important to clean your brushes properly and keep them in excellent condition. To thoroughly clean them:

1. Gently flip-flop each brush back and forth in water until all the paint is removed, rinsing them thoroughly. Never slam brushes into a container and stir them.
2. Work brush cleaner through the hairs of the brush in a small dish and wipe the brush on a soft, absorbent rag. Continue cleaning until there is no trace of color on the rag.
3. Shape the brush with your fingers and store it so nothing can distort the shape of the hairs. Rinse the brush in water before using again.

Sponge Brushes

These are inexpensive brushes that are handy for basecoating a surface or creating your mottled backgrounds for the portrait designs. They clean easily and can be used many times. However, they are very inexpensive and can be thrown away without too much guilt.

When it comes to brushes, please purchase the very best that money can buy. They are your tools – the things you paint with. Occasionally, a student says, "Priscilla, I don't want to buy a good brush until I know I can paint." I always tell my students they won't be able to paint if they don't begin with a good brush. You get what you pay for.

Brush strokes are the basis of my decorative painting technique. This book includes excellent brush stroke worksheets for practicing. To use them, lay a sheet of acetate or tracing paper over the top of the worksheets, choose a brush approximately the same size as the brush used on the worksheet, and practice hundreds of strokes on top of mine. (If a hundred sounds like a lot, get over it! You will find that painting a hundred strokes happens very quickly.)

Palette

You will need a palette for all your painting projects. I like to use a "stay-wet" palette for painting with acrylics. Some people prefer a wax-coated or dry palette for acrylics; however, I prefer a palette that stays wet since acrylics dry so quickly. Palettes can be found where decorative painting supplies are sold. A wet palette consists of a plastic tray that holds a wet sponge and special paper. To use this type of palette:

1. Soak the sponge in water until saturated. Do not wring out, but place the very wet sponge into tray.

2. Soak the paper that comes with the palette in water for 12-24 hours. Place the paper on top of the very wet sponge.

3. Wipe the surface of the paper with a soft, absorbent rag to remove the excess water.

4. Squeeze paint on the palette. When paints are placed on top of a properly prepared wet palette, they will stay wet for a long time.

Palette Knife

Use a palette knife for mixing and moving paint on your palette or mixing surface. I prefer a straight-blade palette knife made of flexible steel.

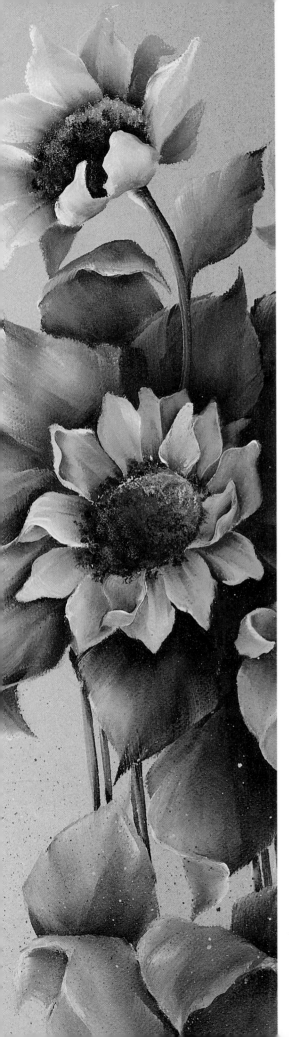

Other Supplies

These are the basic supplies needed for each project. They are not listed in the individual project instructions; you will, however, need to gather them for each and every project.

Sandpaper – I use sandpaper for smoothing canvas and wood surfaces and for creating a distressed, aged look on painted surfaces. Sandpaper comes in various grades from very fine to very coarse. It's good to keep a supply on hand.

Tack Rag – A tack rag is a piece of cheesecloth or other soft cloth that has been treated with a mixture of varnish and linseed oil. It is very sticky. Use it for wiping a freshly sanded surface to remove all dust particles. When not in use, store the tack rag in a tightly sealed jar.

Tracing Paper – I like to use a very thin, transparent tracing paper for tracing designs. I use a **pencil** for tracing.

Graphite Paper or Transfer Paper – In this book, I used white or gray graphite paper to transfer the designs.

Stylus – Use a stylus tool for transferring your traced design to the prepared surface. A pencil or a ballpoint pen that no longer writes also may be used.

100% Cotton Rags – Use only 100% cotton rags for wiping your brush. *Here's a Tip – try the knuckle test: For 15 seconds, rub your knuckles on the rag that you wipe your brush on. If your knuckles bleed, think of what that rag is doing to the hairs of your brush!* You could also use soft, absorbent **paper towels** for wiping brushes.

Water Basin: Use a water basin or other container filled with water for rinsing brushes.

Varnish: Varnish protects your finished painting. It's important to use a varnish that is compatible with the paint you used for the project. Most oil painters use a damar varnish over painted canvases. This is a resin-based varnish that is supple and resists cracking with age. When using acrylics on canvas, use a damar varnish or a varnish made specifically for acrylics. If painting with acrylics on a wooden surface that might get used or be subject to handling, then choose a protective varnish.

BASIC INFORMATION
Transferring a Pattern

You will need:

Tracing paper

Transfer paper, gray or white, depending upon color of background.

Pencil

Stylus

Here's How:

1. Start by neatly tracing the pattern for the design onto tracing paper. Place the tracing paper over the pattern in this book and trace. You may use a pencil or a pen. It is not necessary to trace shading lines or curlicues. Enlarge this design, if needed, to the size to fit your project. Trace this design again onto tracing paper; or photocopy the enlargement onto tracing paper.

2. Position the traced design onto your canvas. Slide a piece of transfer paper between the traced design and your canvas. Tape in place.

3. Using a stylus, go over the lines. Don't press too hard.

4. The design will transfer to the canvas.

Flyspecking

Flyspecking adds an aged look. To flyspeck, you will need:
- *An old toothbrush*
- *Glazing medium*
- *Mixing surface such as a palette or a plastic container.*
- *Dark colored paint*
- *A palette knife*

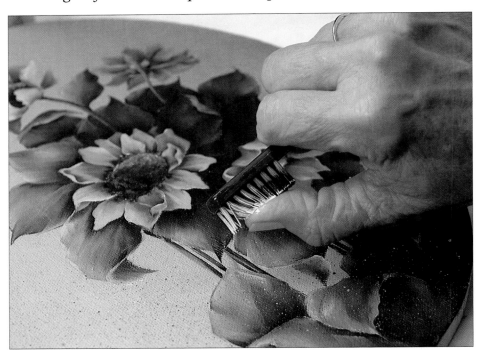

1. Place a small amount of paint on your mixing surface. Add glazing medium, and mix with a palette knife to a very thin consistency. (The thinner the paint, the finer the specks. Thicker paint makes larger specks.) Dip the bristles of the toothbrush in the thinned paint.

2. Point the toothbrush at your painting and pull your thumb across the bristles releasing small spatters of paint over the surface. *Option:* Use a palette knife instead of your thumb and pull the blade of the knife across the bristles of the toothbrush.

Finishing Your Piece

Your painted pieces needed to be protected from dust, dirt, wear and tear. Even if it is a canvas on the wall, it will still get dust on it. Coating it with a finish will protect the paint and allow you to wipe off the dust without harming the painting.

For your canvas paintings, apply one or more brush on coats of **damar varnish** or a **varnish made especially for acrylics.** Apply the varnish with a soft bristle brush.

I use a **matte sealer spray** to protect acrylic paintings on mat board. You will need only a light coating of the spray sealer.

To protect the painted surface of wood or pressed fiberboard, I apply one or more coats of **brush-on varnish** to the paintings after the paint is completely dry and cured. It's important to use a clear-drying finish that's chemically compatible with the paint you used, such as a waterbase varnish with acrylics.

PAINTING TIPS

- When loading a brush with a different color, but one that is in the same color family, it is preferable to wipe the brush on a damp paper towel to remove excess paint before loading a new color. Avoid rinsing the brush too often in water.

- When loading your brush with a color in a different color family, the brush does not need to be thoroughly cleaned. Simply rinse in water and blot brush on a paper towel to remove excess water. Then load the brush with a new color.

- Sometimes I paint with a "dirty brush." Leaving some of the color in the brush from another element seems to blend the colors together better. For example, if I want to add a reddish tint to a leaf, I will leave a little green in my brush when I load the red so that the colors can "marry" together.

Painting Terms

Basecoating

Preparing and painting your project surface before the decorative painting is applied.

Basic Brush Strokes

Basic brush strokes are done with round and flat brushes. Brush strokes are like the letters of the alphabet. They are easy to learn, but they do require practice. Learning these are very important as they are the basis for all of your painting. For example, if you are painting a flower petal, such as a daisy, paint each petal with one brush stroke such as a teardrop. Use as few strokes as possible to paint each part of the design.

Color Wash

A color wash is an application of very thin paint. Actually, one could say it is water with just a little color in it that is applied over a painted surface to add a blush of color. A wash can also be made with glazing medium and a bit of color.

Consistency

Consistency describes the thickness or thinness of the paint. You need different consistencies for different techniques. When you do brush strokes, the paint must be a creamy consistency. When you do line work, the paint must be very thin like the consistency of ink. If the paint is too thick, add a few drops of water to the paint puddle on your palette and mix with a palette knife until the proper consistency is reached.

Contrast

Contrast is the sharp difference between two or more colors. When two colors meet, one edge must be light (usually the top edge) and the other edge or shadowed area must be dark. Contrast gives life to your painting.

Curing

When something is dry to the touch, it is not cured. If something is cured, it is dry all the way through. I often explain curing with this analogy: If you fall down and skin your knee and it bleeds, it's wet. When the scab forms, it's dry. When the new skin grows, it's cured.

I am frequently asked how long it takes a painted piece to cure. There is no right answer – curing depends upon the temperature, air circulation, humidity, the paint color used, and the thinness or thickness of the paint. When a piece is cured, it feels warm and dry to the touch. Curing can take three hours or several weeks.

Double-Loading

Double-loading is a technique of loading the brush with two colors of paint. Using two different puddles of paint, load half of the brush with the lighter color and the other half with the darker color. Blend by stroking your brush many, many times on the palette on one side of the brush, then turn the brush over and stroke on the other side. It takes many strokes to prime a brush and get it good and full of paint.

Outlining

Most of the time, I outline with a #1 liner brush. (It's possible to outline with the very fine point of any good brush.) When outlining, the brush should be full of paint that has been thinned to the consistency of ink.

Undercoating

Undercoating is neatly and smoothly painting a design or part of a design solidly on the basecoated project surface. Your strokes, shading, and highlighting will be done on top of this undercoated design.

Wash

See "Color Wash."

Double-Loading a Flat Brush

Double-loading involves loading your brush with two colors. Be sure to thin paint with water to a flowing consistency and push it with a palette knife to form a neat puddle with a clean edge.

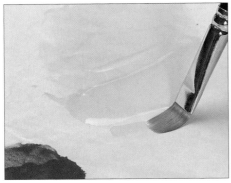

1. Stroke up against the edge of the light color 30 times, so half of the brush is loaded with paint and the other half is clean.

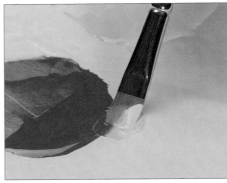

2. Turn the brush over and stroke up against the edge of the dark color 20 times.

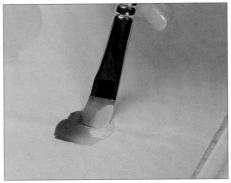

3. Blend, blend, blend one side of the brush on your palette.

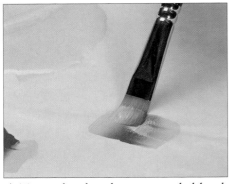

4. Turn the brush over and blend, blend, blend on the other side, keeping the dark color in the center and the light color to the outside.

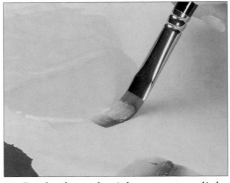

5. Go back and pick up more light paint on the brush.

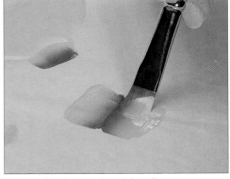

6. Go back to the blending spot on your palette and blend some more.

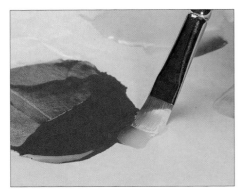

7. Go back and pick up some more of the dark color.

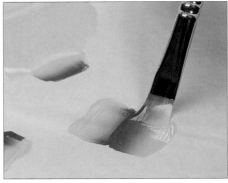

8. Go back to the blending spot on your palette and blend some more. Continue doing this until your brush is really full with paint.

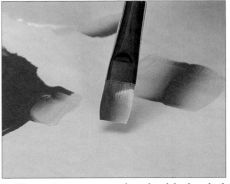

9. Here is a correctly double-loaded brush. You don't want a space between the two colors; you want them to blend into each other in the center of the brush.

Using a Round Brush

Round brushes are used primarily for stroking – we seldom blend with them. They come in a variety of sizes. Practice your round brush strokes on the Brush Stroke Worksheets.

Loading the Brush

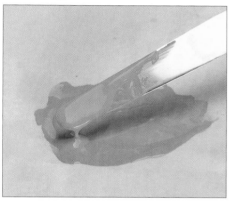

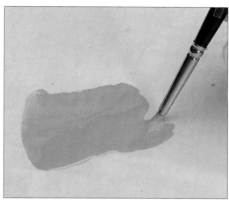

Teardrop or Polliwog Stroke

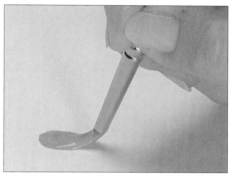

1. Squeeze paint onto your palette. If needed, thin your paint with a thinning medium such as glazing medium or water. Paint should be a creamy consistency.

2. Load the brush by picking up paint from the edge of the puddle.

Touch the tip of the brush to the surface and apply pressure, then gradually lift and drag straight down. Turning the brush slightly left or right forces the hairs back together to form a point.

Using a Liner Brush

Liner brushes are the long, thinner members of the round brush family. The bristles come to a wonderful point. Liner brushes are used for fine line work. Practice your liner brush strokes on the Brush Stroke Worksheets.

Loading the Brush

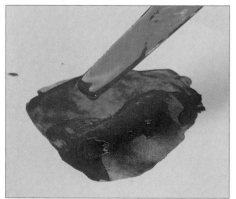

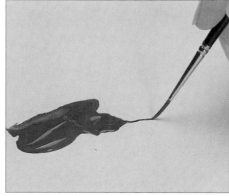

Curlicues & Squiggles

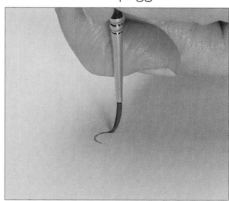

1. Thin paint with water until it is the consistency of ink.

2. Fill the brush full of paint by pulling it through paint puddle. Twist brush as you pull it out of the puddle. this will form a nice pointed tip. When you are using the brush hold it straight up.

Stand the brush on its point with the handle pointing straight up toward the ceiling. Slowly move the brush to paint loopy Ms and Ws. Practice several times on your page. Make as many variations as you wish.

Brush Strokes Worksheet

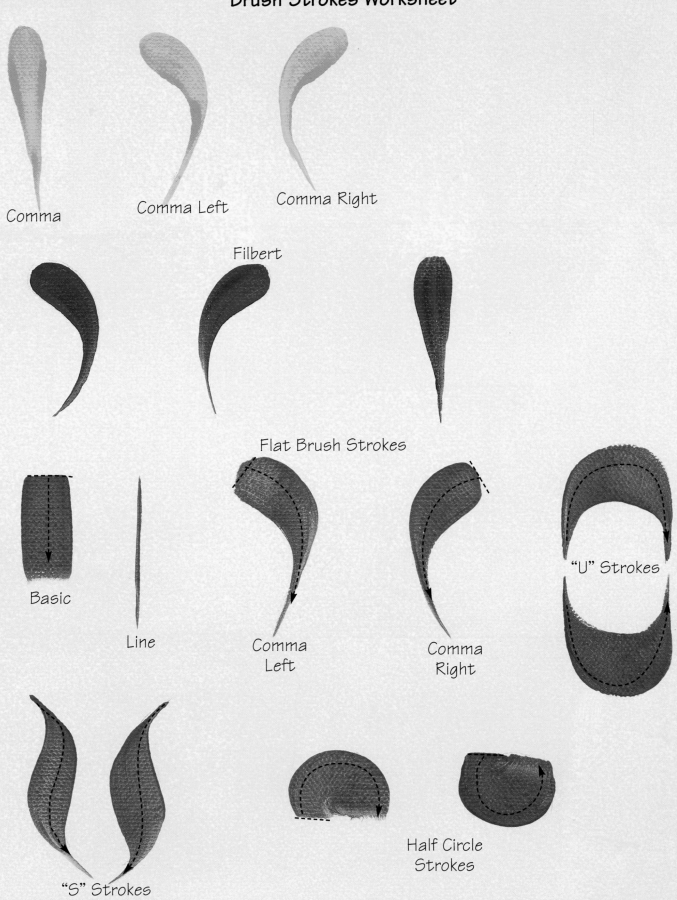

Comma

Comma Left

Comma Right

Filbert

Flat Brush Strokes

Basic

Line

Comma Left

Comma Right

"U" Strokes

"S" Strokes

Half Circle Strokes

Brush Strokes Worksheet
Double Loaded Size 12 Flat Brush

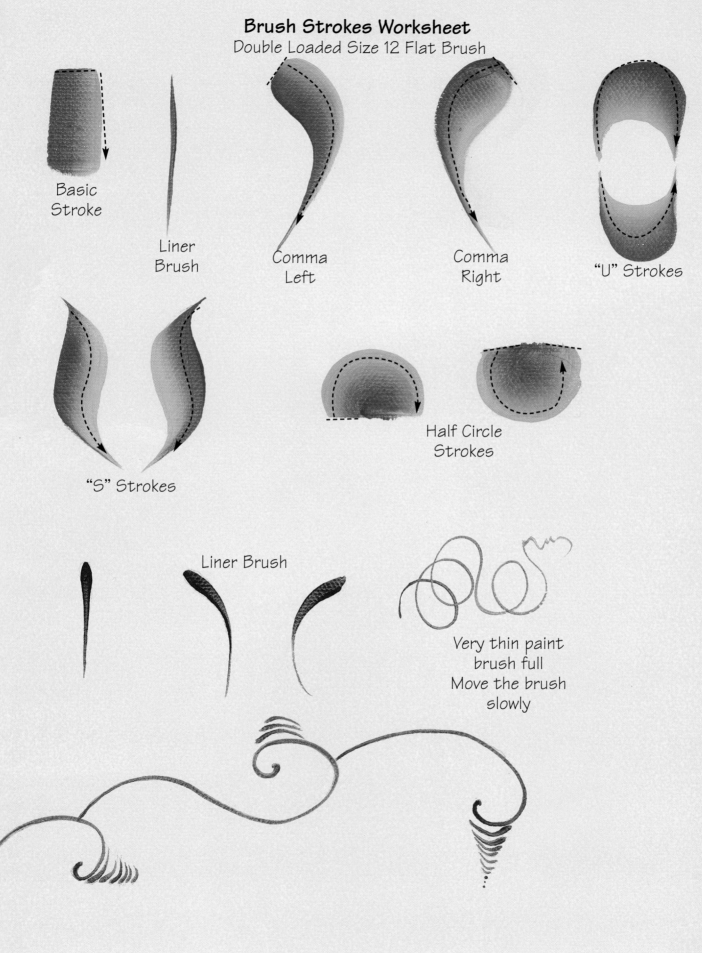

Basic
Stroke

Liner
Brush

Comma
Left

Comma
Right

"U" Strokes

"S" Strokes

Half Circle
Strokes

Liner Brush

Very thin paint
brush full
Move the brush
slowly

How to Float

Floating is flowing color on a surface. This technique is used for adding shading and highlighting to design elements or shading around a design. Before floating shading or highlighting, undercoat the area. Let dry. Add a second or even a third coat, if necessary. Let dry. Our example shows shading and highlighting floated on a leaf.

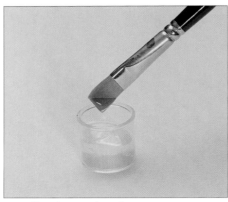

1. Fill as large a brush as you can use on the surface with floating medium.

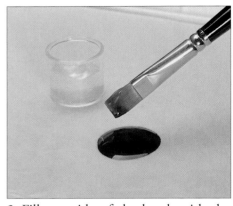

2. Fill one side of the brush with the shading color by stroking up against the edge of a puddle of paint. This is called sideloading.

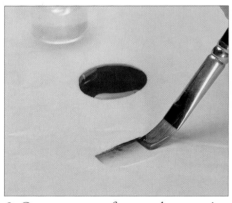

3. On a matte surface, such as tracing paper or wet palette paper, blend, blend, blend on one side of the brush.

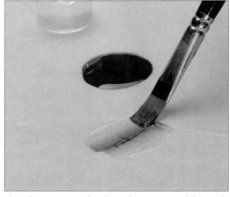

4. Then turn the brush over and blend, blend, blend on the other side. Keep the paint in the center. The color should graduate through the brush from dark to medium to clear.

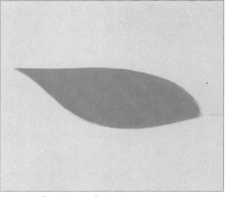

5. The floating of shading and highlighting is done atop the undercoating. Here the leaf has been undercoated with Bayberry.

6. Float on the shading to the edge of the design (leaf). Have the dark side of the brush towards the outside of the design. Let dry. Repeat the process, if desired, to deepen the color.

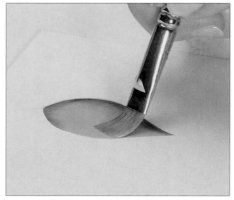

7. Highlighting is floated on the opposite side of the design. Highlighting is done using the same techniques as shading but is done with a lighter color. The paint side of the brush is towards the edge of the design.

Option: Instead of floating medium, water can be used. Fill the brush with water and gently pull the brush along the edge of your water basin to blot.

How to Blend

In this book, I have done a very easy type of blending. First, neatly and carefully undercoat the design area with paint and let dry. Blending medium is used for this technique – it allows you to blend colors together.

1. Float on the shadows. Let dry.

2. Add a small amount of blending medium to the design area.

3. Add the colors you wish to blend on top of the wet medium.

4. Lightly blend or move the colors together, using an extremely light touch. If you are heavy handed, you will wipe all the color away. If this happens, let the blending medium dry and cure and begin again *or* remove the color before it dries, add more blending medium, and begin again.

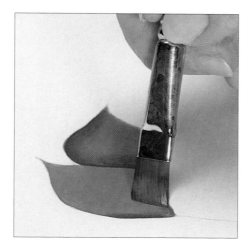
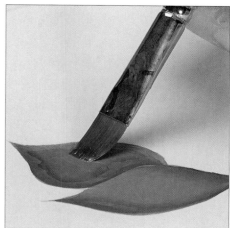
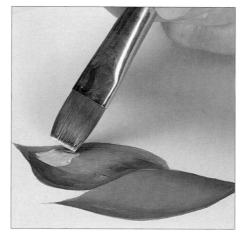
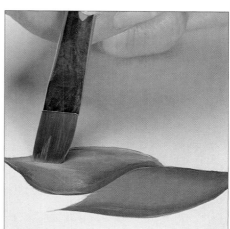

Shadowing Around a Design

Floating shadows around a design is one way to add dimension and interest to a background. You can shadow a design after painting (as shown here) or after the design is transferred but before you start to paint the design.

1. Sideload a brush that is loaded with floating medium with Green Umber. (For instructions on loading the brush, see "How to Float.")

2. Pull the brush around the outside edge of the design, with the dark part of the brush against edge of design.

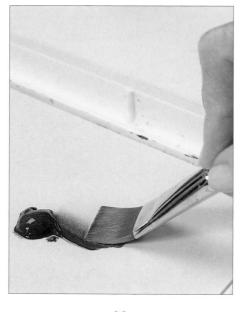
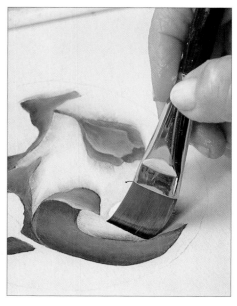

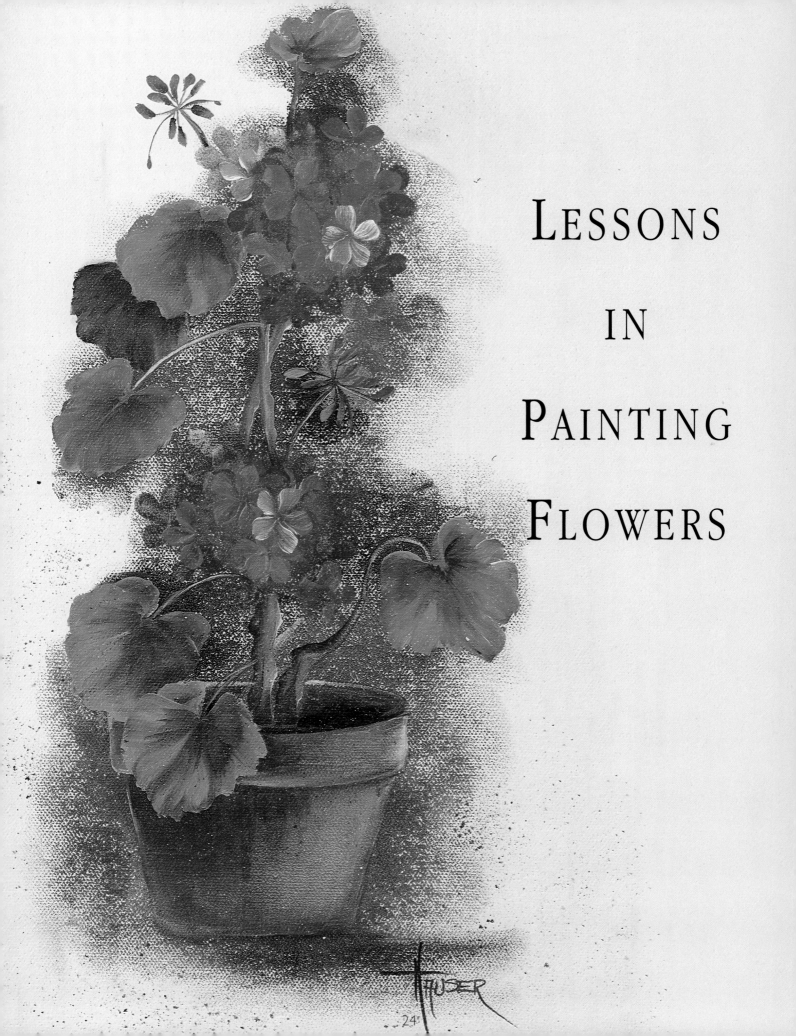

LESSONS

IN

PAINTING

FLOWERS

Flowers are one of God's greatest gifts, whether as a fragrant bud about to burst into a medley of color, or a full-blown blossom that turns its face to catch the first hint of sunshine. In this book I tried to capture some of their remarkable beauty and to give good starting points for you to begin painting your own flower portraits.

I have included nine popular spring and summer flower varieties. Each project includes step-by-step instructions; most have numerous examples illustrated on painting worksheets, plus photographs that show painting the designs.

After you've painted the projects in this book, continue to grow your flower portrait garden with any flower you love. Look around and absorb the botanical beauty of the season. Then, start painting.

Painting Graduated Backgrounds

Graduated backgrounds take practice. The backgrounds for the worksheets in this book are graduated backgrounds, as are many of the original canvases. The idea is to go gradually from dark to medium to light. Here's how to create the graduated background:

1. Start with pre-primed canvas. Sand the canvas with fine sandpaper and wipe with a tack cloth.

2. Using a large sponge brush, dampen the canvas with water.

3. Load the brush with white paint or gesso.

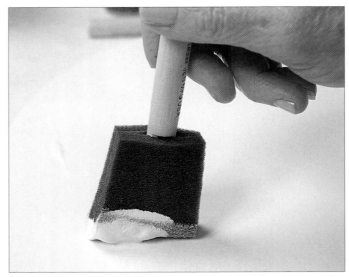

4. Paint about 3/4 of the canvas with this color, leaving the darkest edge unpainted.

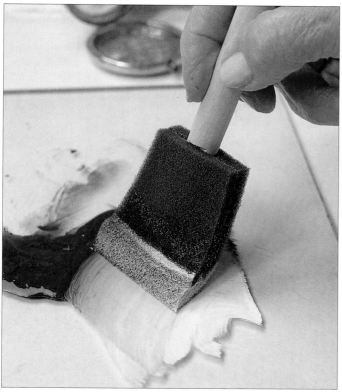

5. Sideload the same dirty sponge brush with a darker color.

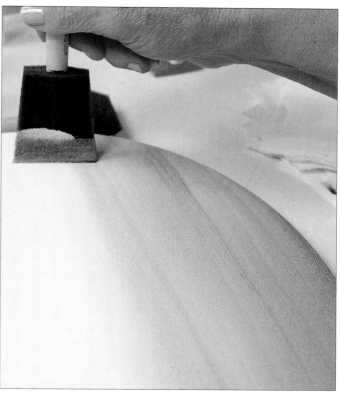

6. Paint the edge of the dark side of the canvas with streaks of this color.

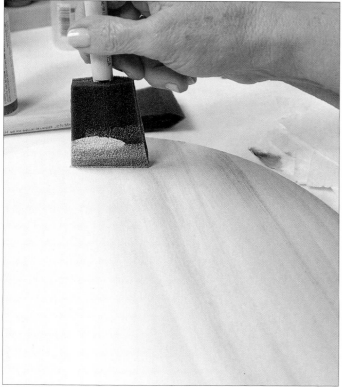

7. Using a large sponge brush, blend the light color into the dark, then blend the dark color into the light as you move the brush across the canvas. Wipe the brush often and keep the brush wet as you work, adding more white or colored paint as needed.

8. Finish blending with a dry sponge brush. Let dry.

ROSES PORTRAIT

Roses are and will be forever the favorite flower of many. They speak in every language, and they express so many different things – love, happiness, joy, sorrow, and forgiveness. I think perhaps my greatest joy is painting the rose.

Before you begin your flower portrait on canvas, practice the strokes using the worksheets that follow the project instructions. When you have painted the first 13 strokes, stop. Paint them over and over and over again, until you have them down. Then continue with the additional strokes. Continue with fill-in strokes to cover any remaining open spaces. Each rose is different.

Let's paint roses!

PALETTE OF COLOR

Artist Pigment Acrylics:

Burnt Carmine Green Dark Green Light Green Medium

Green Umber Ice Blue Dark Raw Umber Titanium White

Acrylic Craft Paint:

True Burgundy Warm White Wicker White

SUPPLIES

Painting Surface:
Canvas oval, 11" x 14"

Brushes:
Flats – #2, #8, #10, #12, #14
Liner – #1
Sponge brushes – 1", 2"

Medium:
Blending medium

Other Supplies:
Oval frame
plus the basic supplies listed on page 14.

Continued on page 30

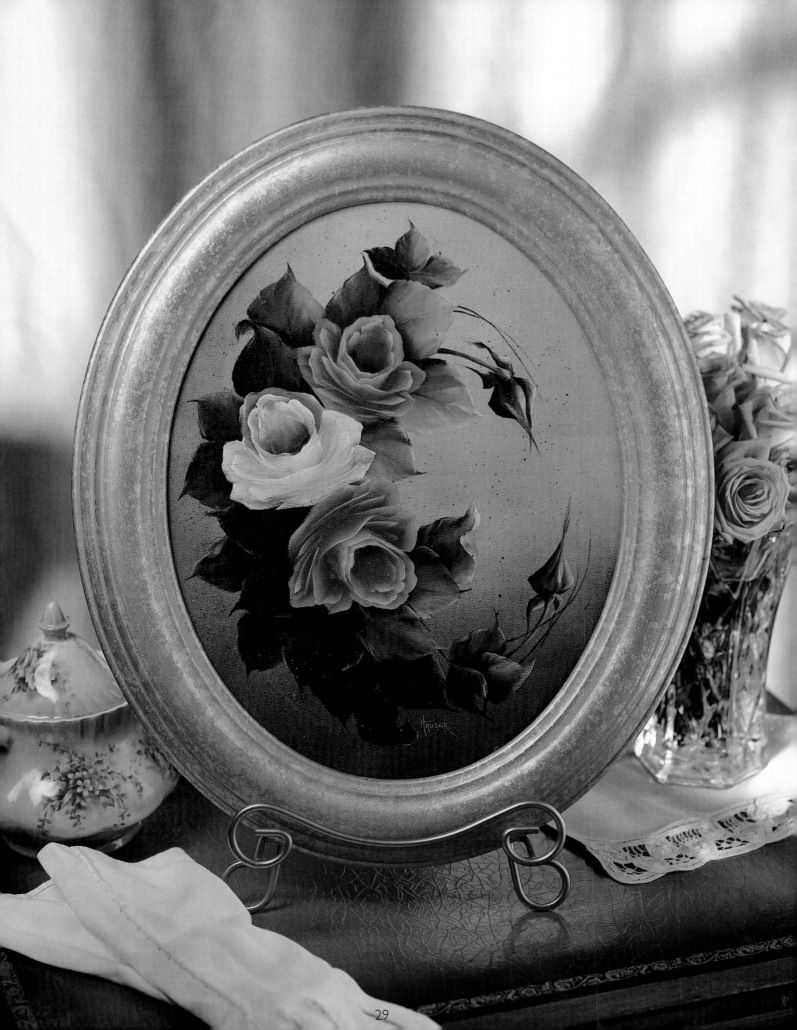

PREPARATION

See the Roses Background & Leaves Worksheet for an example of this background. The figure numbers refer to those on the Worksheet.

1. Lightly sand the canvas with the fine grade sandpaper.
2. Wipe any dust away with a tack cloth.
3. Mix three parts True Burgundy + two parts Raw Umber (3:2).
4. Lightly dampen the canvas with water. Water must not stand or puddle on the canvas, but the canvas should be wet. (Fig. 1)
5. Using the sponge brush, apply the paint mixture to about one-third of the canvas on the left side. (Fig. 2)
6. Using a clean sponge brush, apply Wicker White on the remaining portion of the canvas. (Fig. 2)
7. Wipe your brush and blend the light into the dark. Wipe the brush frequently and then blend the dark into the light. (Fig. 3) You want a lovely graduated background from dark to medium to light. Let the canvas dry.
8. Neatly trace and transfer the design.

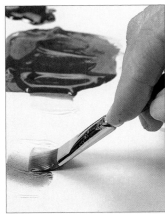

3. *Blending the brush on a palette, keeping the brush in one place.*

4. *Turning over the brush and blending in the same place on the palette.*

2. Add colors to the leaves with the True Burgundy/Raw Umber mix, Green Dark, Raw Umber, Ice Blue Dark, and Warm White, varying the colors – some should be darker, some should be lighter. Blend. See the Leaves Worksheet, Fig. 9 on page 41 for an example.

Blended Leaves:

See the Roses Background & Leaves Worksheet, Fig. 4 (page 37) for examples. For step-by-step examples for painting blended leaves, see the photo series "Painting Blended Leaves" and the Blended Leaves Worksheet (pages 38-41).

1. Undercoat the leaves with Green Medium. Two or three coats will be needed to cover. Let dry.
2. Paint the leaves, following the instructions on the Blended Leaves Worksheet.

1. *Double loading the brush, first with the light color.*

2. *Double loading the brush with the second (dark) color.*

PAINTING THE DESIGN

Shadow Leaves:

See the Shadow Leaf Worksheet (page 40) and the Roses Background & Leaves Worksheet, Fig. 4 (page 37) for examples. Begin with the leaves at the back of the design, and paint one leaf at a time.

1. Undercoat the leaves with the True Burgundy/Raw Umber mix. Two or three coats will be needed to cover. Let dry.

5. *Painting the first stroke.*

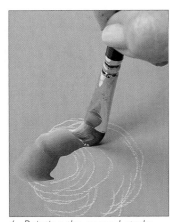

6. *Painting the second stroke.*

Roses:

The rose is built of many double-loaded brush strokes. Your brush must be in excellent condition and full of paint that is a flowing consistency. If you are left-handed, stroke from right to left; if right-handed, stroke from left to right. The photographs that accompany this project show you how I paint roses. The figure numbers in parentheses after the steps refer to the Rose Worksheet, on pages 34 and 35.

1. Make a dark mixture of four parts True Burgundy + one part Raw Umber (4:1). Undercoat the roses with this dark mix. Let dry.
2. Take some of the dark mixture and add Titanium White (one part dark mix, five parts white, 1:5).
3. With a double loaded brush, paint the first stroke at the top of the rose. This is a scalloped stroke. (Fig. 1)
4. For the second stroke, paint a scallop-like comma stroke on the right. (Fig. 2)

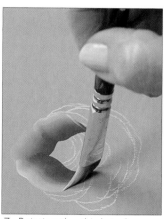
7. *Painting the third stroke.*

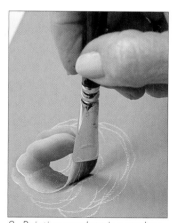
8. *Painting overlapping strokes.*

5. Paint a scallop-like comma stroke on the left for the third stroke. (Fig. 2)
6. Double load your brush with more paint + a lighter value on the light side. Paint the fourth stroke – a small scallop stroke between strokes 1 and 3. (Fig. 3)
7. Paint the fifth stroke – a scallop stroke on the right of stroke 4 with the same colors. (Fig. 3)
8. Paint the sixth stroke – a scalloped comma stroke on the right that overlaps stroke 2. (Fig. 4)
9. Paint stroke 7 – a scalloped comma on the left that overlaps stroke 3. (Fig. 4)
10. Notice the four tails of the comma strokes (labeled A, B, C, and D on the Rose Worksheet, Fig. 4.) Double load your brush. Begin stroke 8 at the left, starting at the outside edge of tail B. Finish the stroke by connecting to the outside edge of tail C on the right. (Fig. 5)

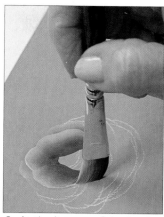
9. *At the bottom of the bowl, starting the connecting stroke.*

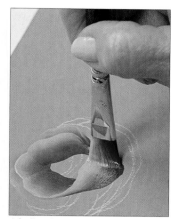
10. *Finishing the connecting stroke at the bottom of the bowl.*

11. Double load the brush and paint a scalloped comma on the right – this is stroke 9. (Fig. 6)
12. Repeat this on the left for stroke 10. (Fig. 6)
13. Paint stroke 11 – a scalloped comma on the right. (Fig. 7)
14. Paint stroke 12 – a scalloped comma on the left. (Fig. 7)
15. Paint stroke 13 – a sideways S-stroke that connects the tails of strokes 11 and 12. (Fig. 7)
16. Paint stroke 14 – a broken U-stroke that connects tail A and tail D. Double load the brush. Start at tail A, pull, press, and lift in the middle. (This breaks the stroke.) Place the brush down again and pull, press, and lift to complete the petal. (Fig. 8)
17. Paint stroke 15 – a fill-in stroke. (Fig.9.)
18. Paint stroke 16 on the left to the inside of stroke 10. (Fig. 9)
19. Paint stroke 17 on the right, overlapping stroke 11. (Fig. 10)
20. Paint stroke 18 on the left, overlapping stroke 12. (Fig. 10)
21. Paint stroke 19, filling in at the bottom. (Fig. 10)
22. Paint stroke 20, filling in on the left. (Fig. 11)
23. Paint additional strokes to fill any open spaces.
24. Paint the flower center by creating little scallop strokes, using a double loaded brush. (Fig. 12)
25. Highlight the rose center at the top, and finish the center with a rolled S-stroke.

Rosebud & Calyx:

See the Rosebud Worksheet on page 36.

1. Double load a brush with True Burgundy and a light pink mix (one part True Burgundy + four parts Titanium White, 1:4). Stroke the bottom. (Fig. 1)

Continued on next page

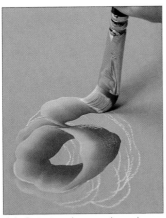

11. *Painting the petal on the right edge.*

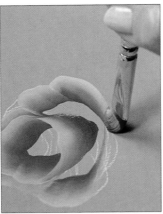

12. *Painting the petal on the left edge.*

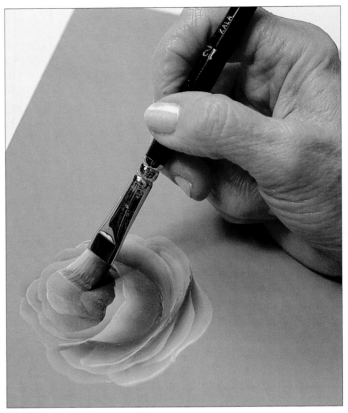

15. *Highlighting the top of the rose center.*

Continued from page 31

2. Apply S-strokes on either side. (Fig. 2)
3. Blend. (Fig. 3)
4. Float Green Umber shadows to begin the calyx. (Fig. 3)
5. Double load a brush with Green Umber and Green Medium. Paint the calyx with three S-strokes. (Figs. 5 and 6.)
6. Highlight calyx with Warm White. (Fig. 5.)

Stems:
1. Paint the stems with Green Medium.
2. Shade with Green Umber.
3. Highlight with Titanium White. Let dry and cure.

FINISHING
Apply one coat of finish. ❏

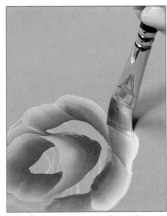

13. *Painting the strokes along the bottom.*

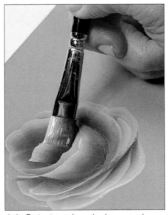

14. *Painting the darker strokes that form the center of the rose.*

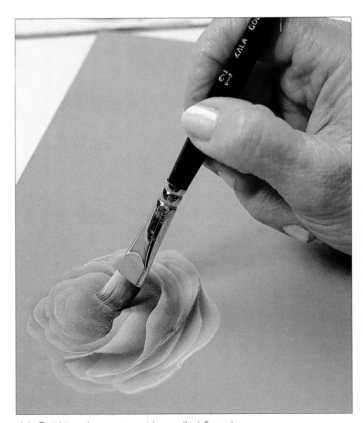

16. *Finishing the center with a rolled S-stroke.*

Pattern

Enlarge pattern @125% for actual size.

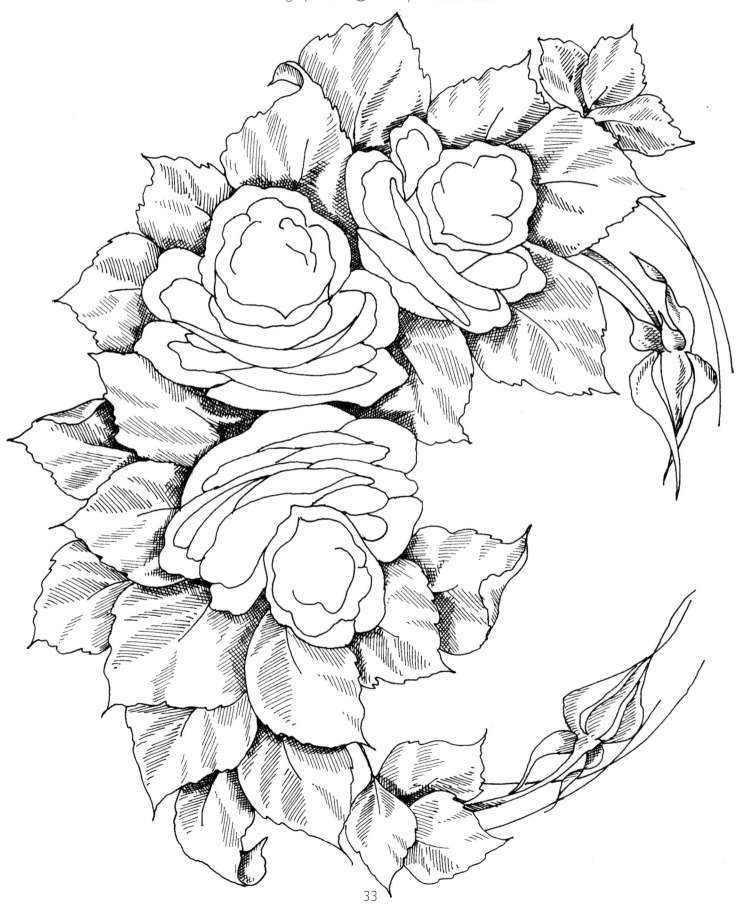

Rose Worksheet

Fig. 1

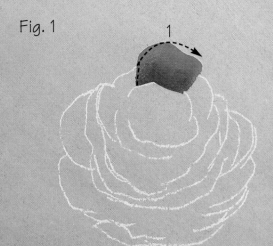

Fig. 2

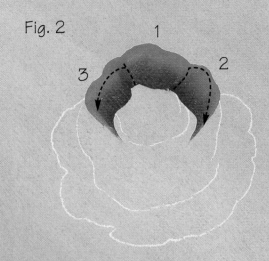

Fig. 3

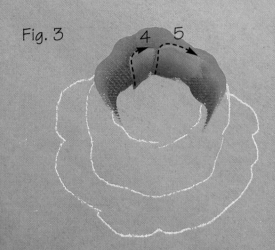

Fig. 4

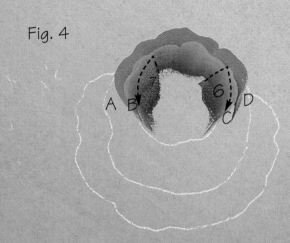

Fig. 5

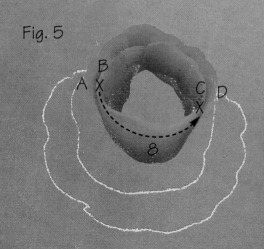

Fig. 6

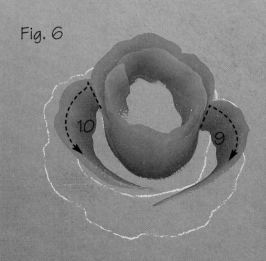

Rose Worksheet

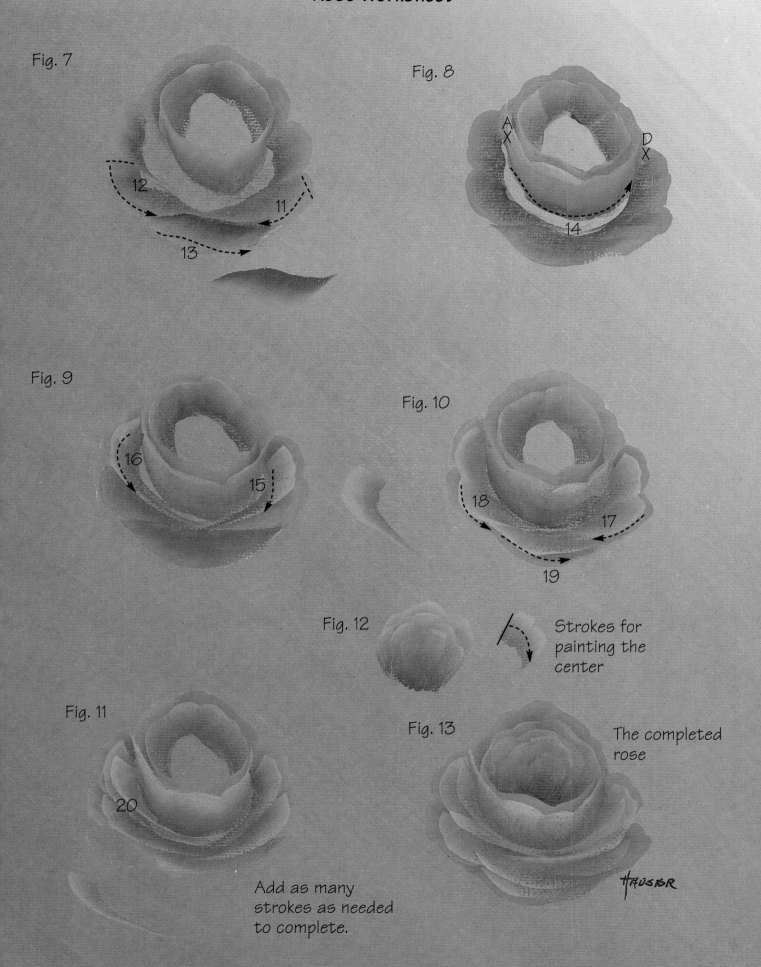

Fig. 7

12

11

13

Fig. 8

A
X

D
X

14

Fig. 9

16

15

Fig. 10

18

17

19

Fig. 12

Strokes for
painting the
center

Fig. 11

20

Fig. 13

The completed
rose

Add as many
strokes as needed
to complete.

Rose Bud Worksheet

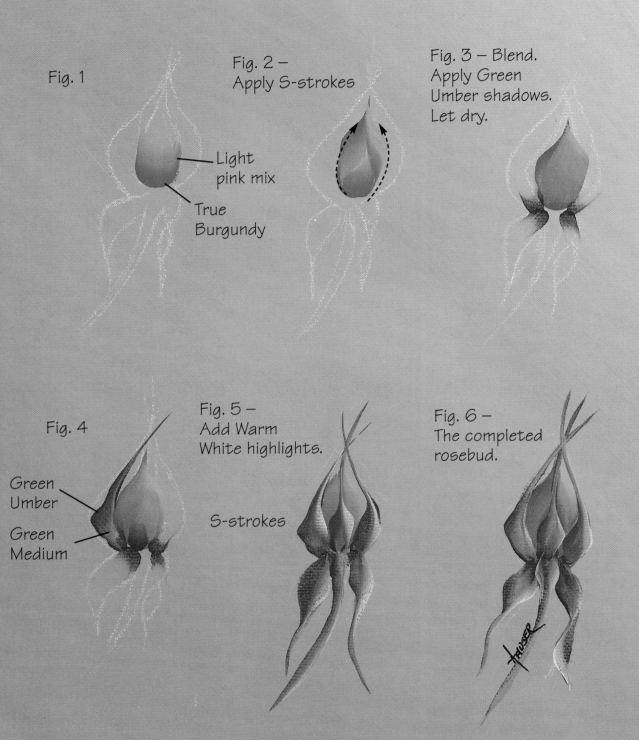

Fig. 1

Light
pink mix

True
Burgundy

Fig. 2 —
Apply S-strokes

Fig. 3 — Blend.
Apply Green
Umber shadows.
Let dry.

Fig. 4

Green
Umber

Green
Medium

Fig. 5 —
Add Warm
White highlights.

S-strokes

Fig. 6 —
The completed
rosebud.

Roses Background & Leaves Worksheet

Fig. 1 – Lightly dampen the canvas with water.

Fig. 2 – Using a sponge brush, apply the dark paint mixture to about one-third of the canvas. Using a clean sponge brush, apply Wicker White to the remainder of the canvas.

Fig. 3 – Wipe your brush and blend light into dark, then dark into light.

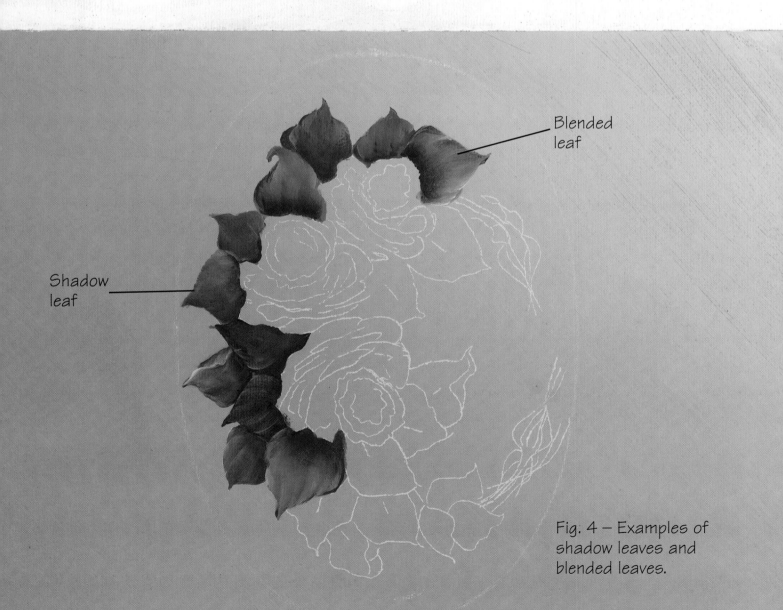

Blended leaf

Shadow leaf

Fig. 4 – Examples of shadow leaves and blended leaves.

PAINTING LEAVES

These photos show you the steps in painting broad leaves,
such as the leaves in the Lilacs Portrait.

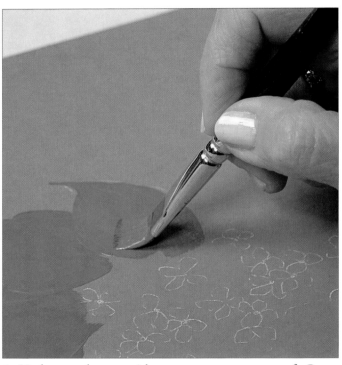

1. Undercoat leaves with one or more coats of Green Medium.

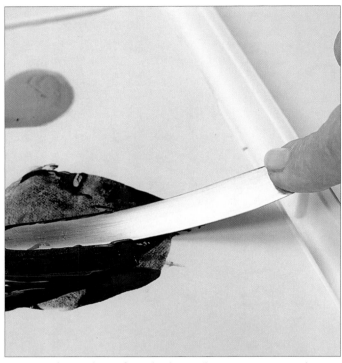

2. Mix the colors for shading (here, Burnt Umber + Prussian Blue). Mix paint on palette with a palette knife.

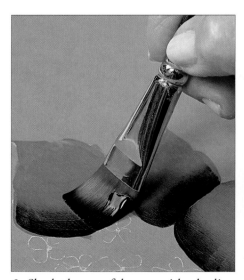

3. Shade bases of leaves with shading mix. Let dry.

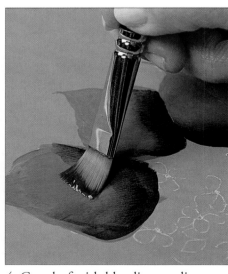

4. Coat leaf with blending medium.

5. Load one side of brush with Green Medium.

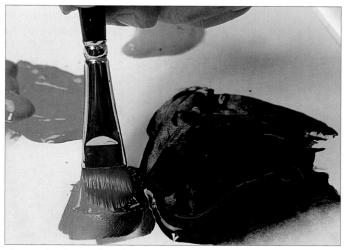

6. Load other side of brush with the shading mix.

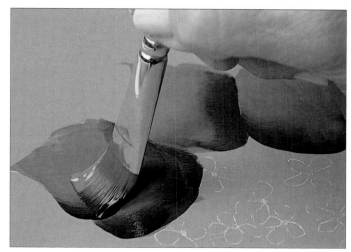

7. With the double-loaded brush, apply brush strokes along the edge of the leaf with the shading mix on the outer edge.

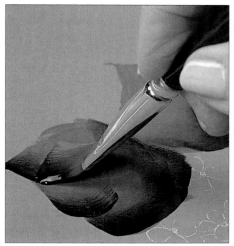

8. Paint an s-stroke to form the tip of the leaf.

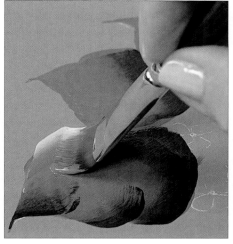

9. Stroke the other edge of the leaf with Warm White + Medium Green on a double-loaded brush.

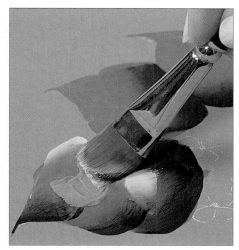

10. Add colors (Green Light, Warm White) to center of leaf.

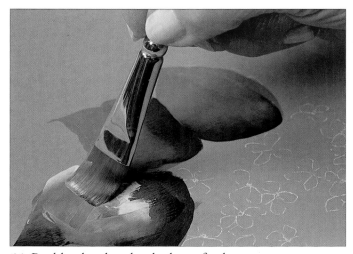

11. Pat blend to lose hard edges of colors.

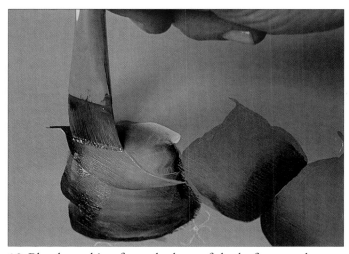

12. Blend, stroking from the base of the leaf outward.

Continued on next page

continued from page 39

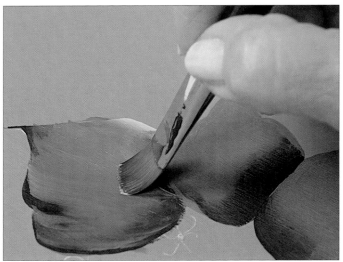

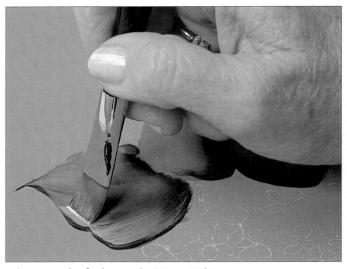

13. Lightly blend, stroking from the outside towards the base.

14. Accent leaf edge with Warm White.

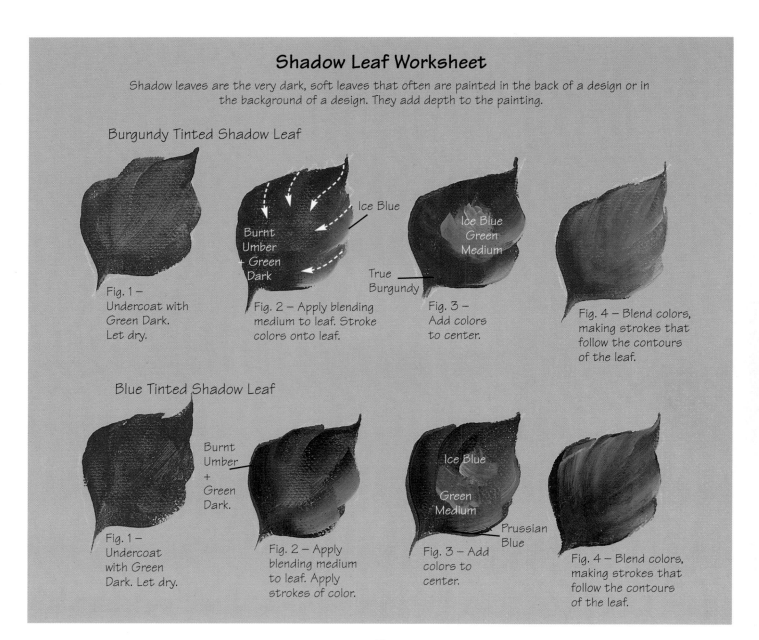

Shadow Leaf Worksheet

Shadow leaves are the very dark, soft leaves that often are painted in the back of a design or in the background of a design. They add depth to the painting.

Burgundy Tinted Shadow Leaf

Fig. 1 – Undercoat with Green Dark. Let dry.

Ice Blue

Burnt Umber + Green Dark

Fig. 2 – Apply blending medium to leaf. Stroke colors onto leaf.

Ice Blue Green Medium

True Burgundy

Fig. 3 – Add colors to center.

Fig. 4 – Blend colors, making strokes that follow the contours of the leaf.

Blue Tinted Shadow Leaf

Fig. 1 – Undercoat with Green Dark. Let dry.

Burnt Umber + Green Dark.

Fig. 2 – Apply blending medium to leaf. Apply strokes of color.

Ice Blue

Green Medium

Prussian Blue

Fig. 3 – Add colors to center.

Fig. 4 – Blend colors, making strokes that follow the contours of the leaf.

Blended Leaves Worksheet

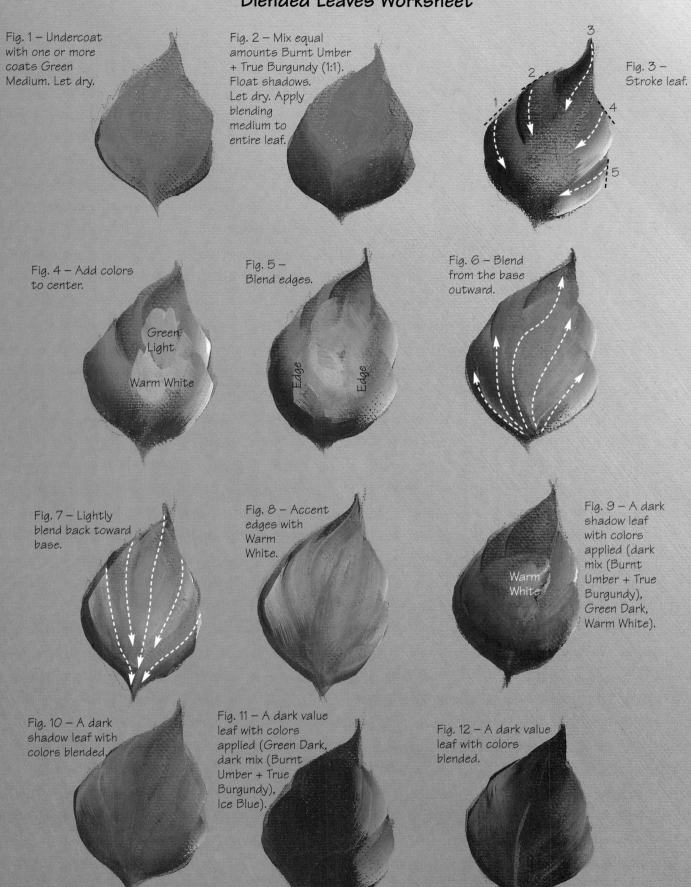

Fig. 1 – Undercoat with one or more coats Green Medium. Let dry.

Fig. 2 – Mix equal amounts Burnt Umber + True Burgundy (1:1). Float shadows. Let dry. Apply blending medium to entire leaf.

Fig. 3 – Stroke leaf.

Fig. 4 – Add colors to center.

Green Light

Warm White

Fig. 5 – Blend edges.

Edge

Edge

Fig. 6 – Blend from the base outward.

Fig. 7 – Lightly blend back toward base.

Fig. 8 – Accent edges with Warm White.

Fig. 9 – A dark shadow leaf with colors applied (dark mix (Burnt Umber + True Burgundy), Green Dark, Warm White).

Warm White

Fig. 10 – A dark shadow leaf with colors blended.

Fig. 11 – A dark value leaf with colors applied (Green Dark, dark mix (Burnt Umber + True Burgundy), Ice Blue).

Fig. 12 – A dark value leaf with colors blended.

41

PAINTING TURNED LEAVES

These photographs show how to paint turned leaves.

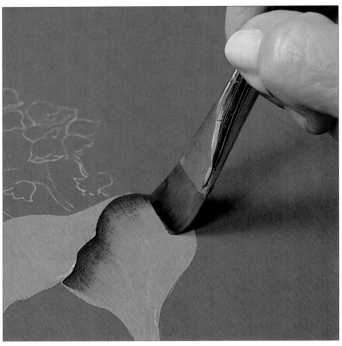

1. Add a shadow color under what will be turned area of leaf.

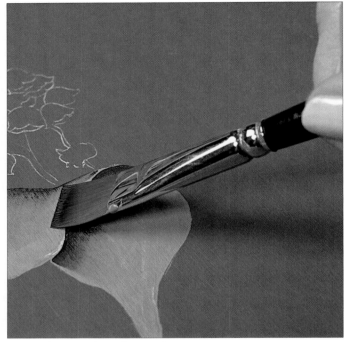

2. Shade top edge of turned area.

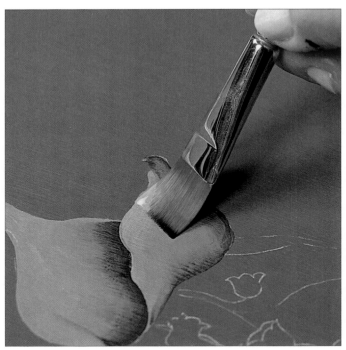

3. Highlight front edge of turned area, using a brush double loaded with yellow mix.

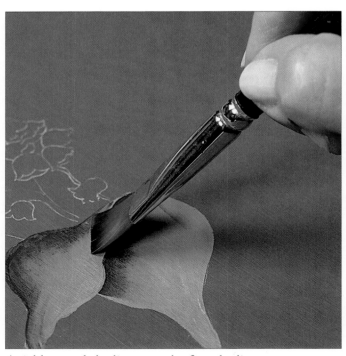

4. Add second shading over the first shading.

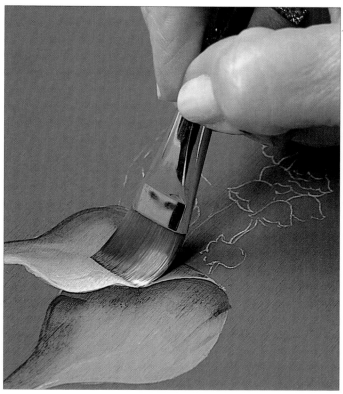

5. Accent with Warm White on front edge of turned area.

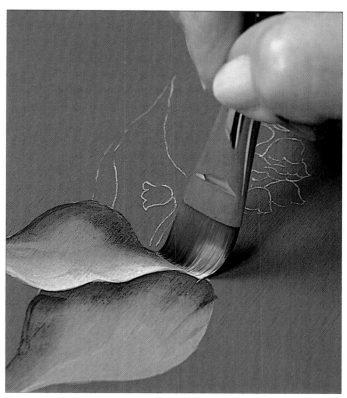

6. Add a float of Warm White along the turned area.

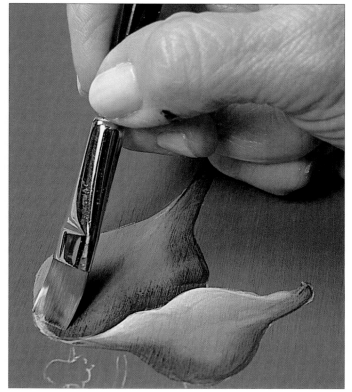

7. Continue the float down the edge of the leaf towards the base.

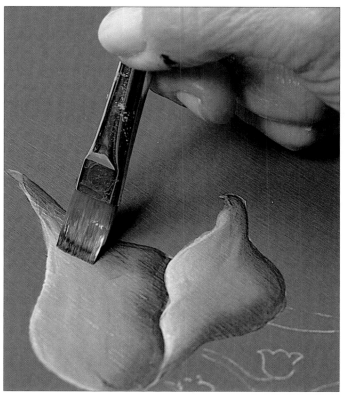

8. Smooth out and blend, if needed, with dry dirty brush.

LILACS PORTRAIT

To me, lilacs are old-fashioned and so beautiful. Their fragrance alone is a miracle.
Painting them is a joy.

PALETTE OF COLORS

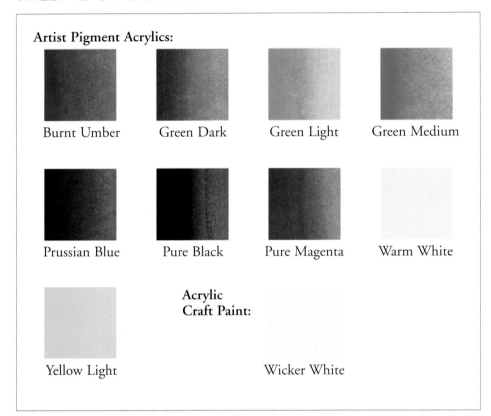

Artist Pigment Acrylics:

Burnt Umber Green Dark Green Light Green Medium

Prussian Blue Pure Black Pure Magenta Warm White

Acrylic Craft Paint:

Yellow Light Wicker White

SUPPLIES

Painting Surface:
Canvas oval, 11" x 14"

Brushes:
Flats – #2, #8, #12, #14
Liner – #1
Sponge brushes – 1", 2"

Medium:
Blending medium

Other Supplies:
Oval frame
plus the basic supplies listed on page 14.

PREPARATION

1. Lightly sand the canvas with fine grade sandpaper.
2. Wipe any dust away with a tack cloth.
3. Lightly dampen the canvas with water. Water must not stand or puddle on the canvas, but the canvas should be wet.
4. Make a blue/purple mix by combining equal amounts of Dioxazine Purple + Prussian Blue (1:1).
5. Using the sponge brush, apply this mixture to approximately one-fourth of the canvas.
6. Using a clean sponge brush, apply Wicker White to the remainder of the canvas.
7. While the paint is wet, quickly wipe your brush and blend the light into the dark. Wipe the brush frequently, then blend the dark into the light. You want a lovely graduated background from dark to medium to light. Let the canvas dry.
8. Neatly trace and transfer the design.

Continued on page 46

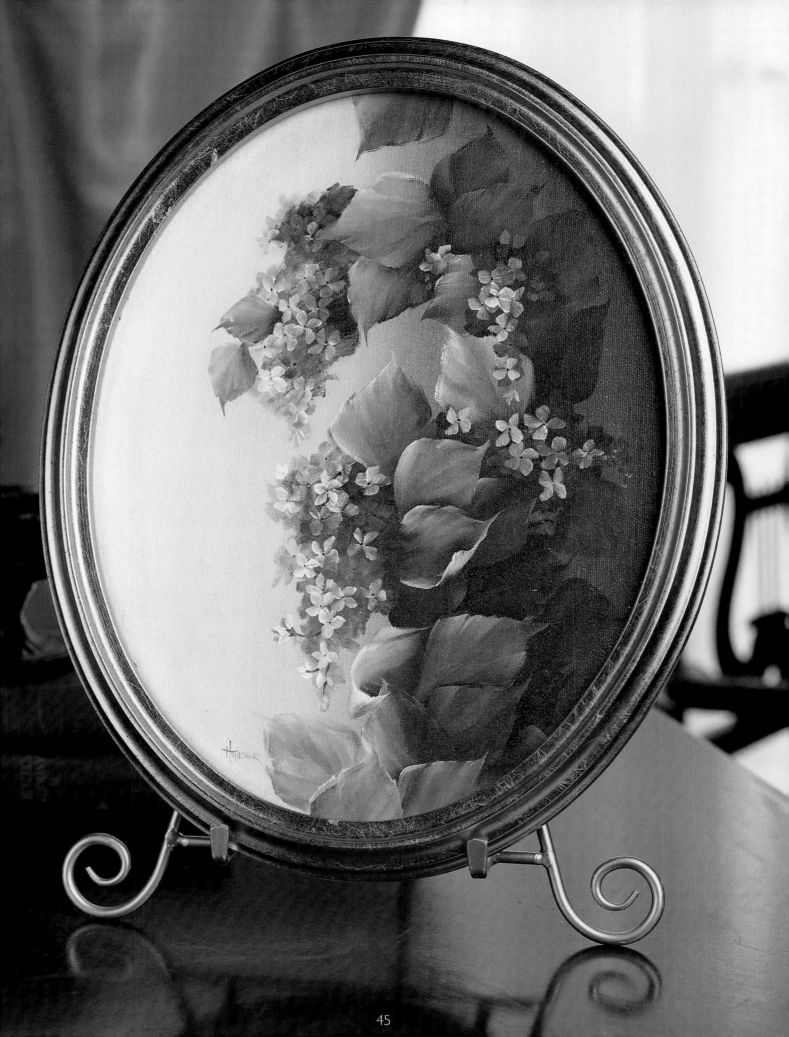

continued from page 44

PAINTING THE DESIGN

Shadow Leaves:

See the Shadow Leaf Worksheet. Begin with the leaves at the back of the design, and paint one leaf at a time.

1. Undercoat the leaves with a mixture of equal amounts of Green Dark + Prussian Blue (1:1). Let dry.
2. Add colors to the leaves with Green Dark, Ice Blue Dark, Burnt Umber + Pure Magenta, and Warm White, varying the colors – some should be darker, some should be lighter. Blend. See the Blended Leaves Worksheet, Fig. 9 for an example.

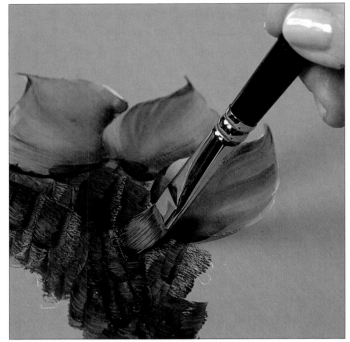

2. Dabbing in the undercoat colors (Pure Magenta + Prussian Blue).

4. Add Green Light and Warm White to center. Blend edges, blend from the base outward, and lightly blend back toward base.
5. Accent edges with Warm White.

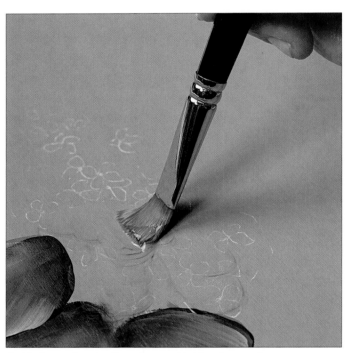

1. Undercoating the lilac clump with blending medium.

Blended Leaves:

See the Blended Leaves Worksheet and the photo series, "Painting Leaves."

1. Undercoat the leaves with Green Medium. Let dry. (Two or three coats will be needed to cover.)
2. Mix equal amounts Burnt Umber + Pure Magenta (1:1). Float shadows. Let dry. Apply blending medium.
3. Stroke leaf to blend.

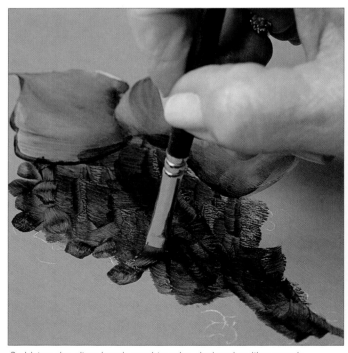

3. Using the dirty brush, stroking the dark value lilac petals.

Lilacs:

Lilac blossoms are small, four-petal flowers. Use the #2 flat brush and stroke from the outside edge in toward the center, as shown on the worksheet, to create the petals. It is not necessary to undercoat the lilacs. See the Lilacs Worksheet.

1. Apply a little blending medium to the canvas.
2. Apply Prussian Blue and Pure Magenta. (Fig. 2)
3. Using a dirty brush, stroke the dark value lilac petals. (Fig. 2)
4. While the paint is still wet, wipe the brush and pick up a little Warm White. Paint a few medium value flowers on top of the dark flowers. (Fig. 3)

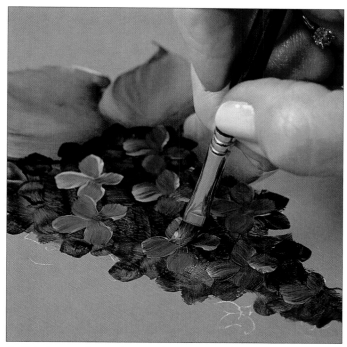

5. Painting medium value petals in groups of four.

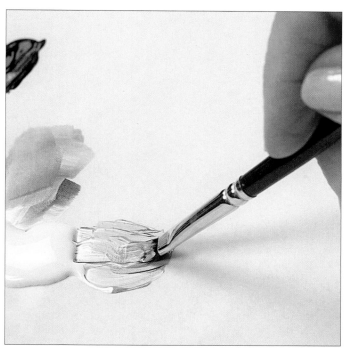

4. Mixing a lighter color on the palette by brush blending Warm White with the color on the brush to create a medium value.

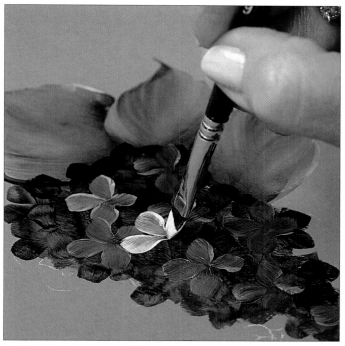

6. After picking up more Warm White, painting a few light value flowers.

5. Wipe the brush and pick up more Warm White. (You want to do this while the clump is still wet to get the beautiful bleed-through of colors from underneath.) Paint just a few of the lightest value flowers on top of the clump. (Fig. 4)
6. Use a #1 liner brush and thinned Yellow Light to paint a tiny dot in the center of each blossom. (Fig. 1)
7. In the center of the yellow, apply the tiniest dot of thinned Pure Black. Let dry. (Figs. 1 and 4)

FINISHING

Apply one coat of finish. ❑

Lilacs Worksheet

Fig. 1 – Paint shadow leaves first, working from back to front. Then paint blended leaves. Paint lilac flowers over leaves. Dot centers with Yellow Light, let dry, then add tiny dots of thinned Pure Black.

Fig. 2 – Apply blending medium, then apply colors. Neatly stroke dark value flowers around edge of clump.

Prussian Blue

Pure Magenta

Fig. 3 – Wipe brush and pick up Warm White. Blend on palette. Paint medium value flowers.

Fig. 4 – Wipe brush and pick up more Warm White. Paint a few light value flowers.

Pattern

Enlarge pattern @130% for actual size.

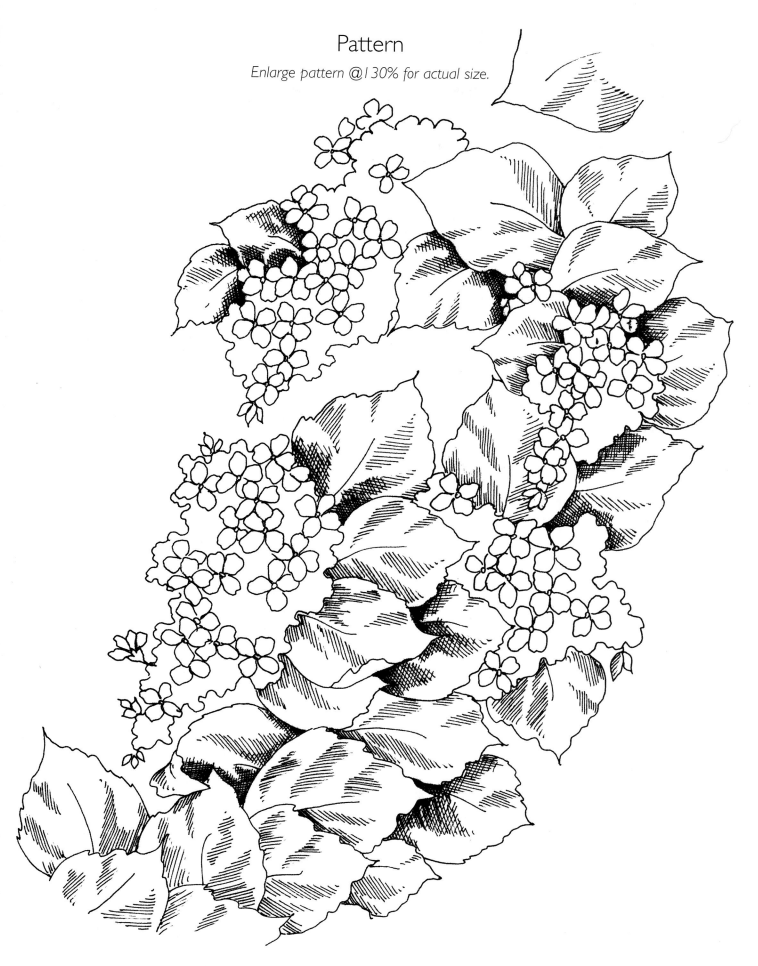

DAISIES PORTRAIT

Is there a happier flower than a daisy? Created with a wonderful combination of brush strokes and blending, they are absolutely magnificent.

PALETTE OF COLORS

Artist Pigment Acrylics:

Asphaltum	Burnt Sienna	Burnt Umber	Green Dark
Green Light	Green Medium	Green Umber	Ice Blue Dark
Prussian Blue	Raw Umber	Red Light	Titanium White
Warm White	Yellow Light		Wicker White

Acrylic Craft Paint:

SUPPLIES

Painting Surface:
Canvas oval, 11" x 14"

Brushes:
Flats – #4, #8, #10, #12, #14
Liner – #1
Sponge brushes – 1", 2"

Medium:
Blending medium

Other Supplies:
Oval frame
plus the basic supplies listed on page 14.

PREPARATION

1. Lightly sand the canvas with fine grade sandpaper.
2. Wipe any dust away with a tack cloth.
3. Lightly dampen the canvas with water. Water must not stand or puddle on the canvas, but the canvas should be wet.
4. Mix equal amounts Green Umber and Raw Umber (1:1).
5. Using the sponge brush, apply the green mix to approximately one-fourth of the canvas.
6. Using a clean sponge brush, apply Wicker White to the remainder of the canvas.
7. While the paint is wet, quickly wipe your brush and blend the light into the dark. Wipe the brush frequently, then blend the dark into the light. You want a lovely graduated background from dark to medium to light. Let the canvas dry.
8. Neatly trace and transfer the design.

Continued on page 52

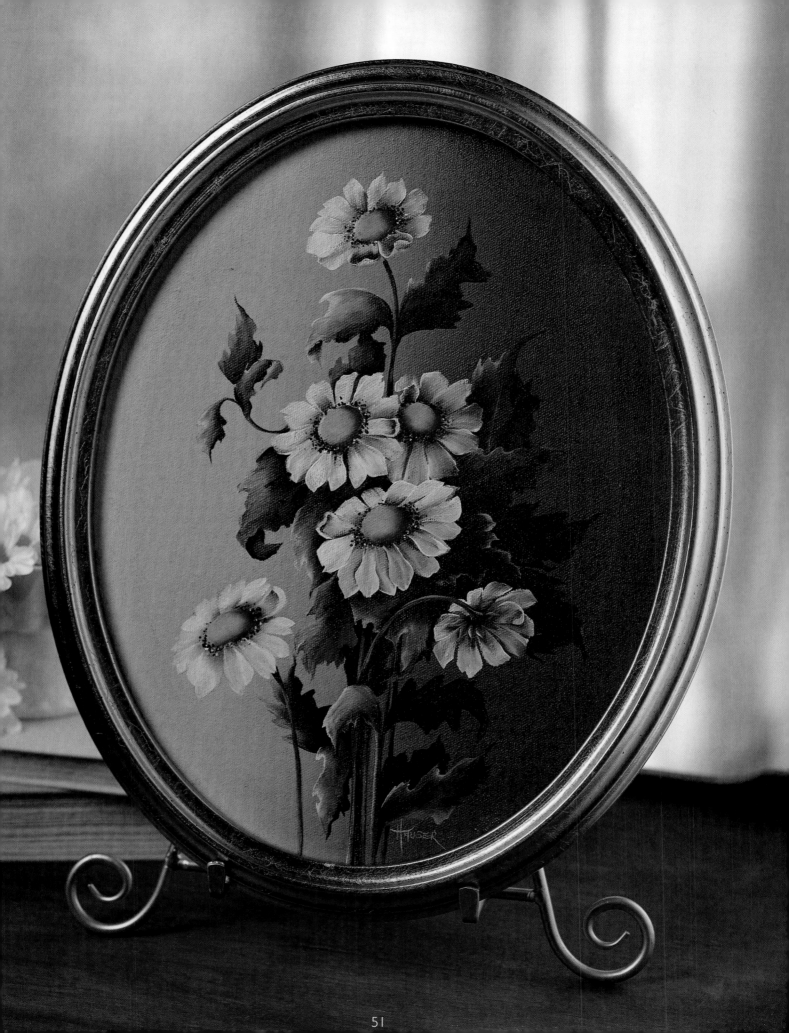

continued from page 50

PAINTING THE DESIGN

Leaf Undercoats:

Create contrast among the leaves by varying the dark, medium, and light colors. Begin with the leaves that are the furthermost back in the design. See the Leaves Worksheets and the photo series on Painting Leaves for examples.

1. Mix three parts Green Dark and one part Prussian Blue (3:1). Undercoat the shadow leaves with this mix. Two or three coats will be needed to cover. Let the paint dry thoroughly between coats.

2. Undercoat the dark leaves with Green Dark. Apply two or three coats and allow to dry between applications.

3. Undercoat the medium value leaves with Green Medium. Apply two or three coats and allow to dry between applications.

4. Undercoat the light value leaves with Green Light. Apply two or three coats and allow to dry between applications.

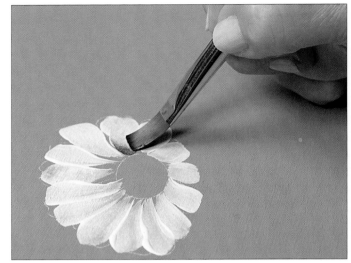

3. Shading the base of each petal.

1. Undercoating the daisy petals with Warm White.

2. Sideloading a brush with Green Umber.

Shadow Leaves:

Paint one leaf at a time.

1. Apply a small amount of blending medium to the leaf.

2. Mix one part Prussian Blue + four parts Burnt Umber (1:4). Float a dark shadow at the base of each shadow leaf where it goes underneath another leaf or flowers. Let dry.

3. Use a small amount of Ice Blue Dark + Warm White to highlight the edge.

Dark Value Leaves:

See the Daisies Worksheet, Figs. 11 through 16. Paint one leaf at a time.

1. Apply blending medium to each leaf. (Fig. 11)

2. Double load your brush with Green Dark and the dark mix (one part Prussian Blue + four parts Burnt Umber, 1:4). With the dark mix to the outside, shade the base of the leaf. (Fig. 12)

3. Again with the dark mix to the outside, "scribble" neatly and slowly back and forth along the dark side to create the rough edge of the leaf. (Fig. 13)

4. Sideloading the same (dirty) brush on the dark side with Burnt Sienna.

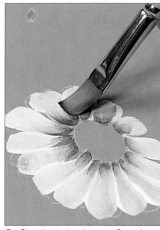

5. Shading the base of each petal on top of Green Umber.

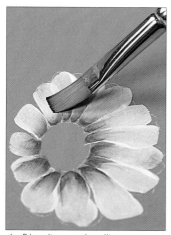

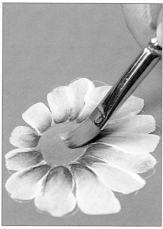

6. Blending and pulling out shading, using a brush dipped in blending medium.

7. Painting the center with Yellow Light.

4. Wipe the brush. Double load with Green Dark and Titanium White. Blend on the palette to soften the color.

5. Turn the leaf upside down. "Scribble" on the light side of the leaf with the light color to the outside edge. (Fig. 13)

6. Add Warm White and Green Medium to the center. (Fig. 14) Wipe the brush and blend from the base of the leaf out toward the edges of the leaf, then blend back toward the base. Use a light touch. (Fig. 15)

7. *Option:* If desired, lightly vein the leaf with the dark mix or Burnt Umber.

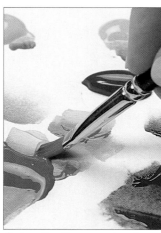

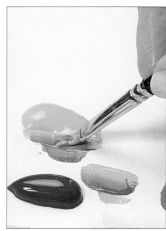

8. Loading the same brush with more Yellow Light, then sideloading with Burnt Sienna.

9. Blending the colors on the brush.

Medium Value Leaves:
Paint the medium value leaves, following the instructions for the dark value leaves, but substitute Green Medium for Green Dark and Green Light for Green Medium.

Light Value Leaves:
Paint the light value leaves, following the instructions for the dark value leaves, but substitute Green Light for Green Dark and Green Light + Warm White for Green Light.

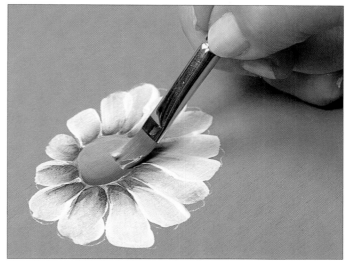

10. Shading the daisy center.

Daisy Petals:
See the Daisies Worksheet, Figs. 5 through 8.
1. Apply blending medium to a few petals at a time.
2. *Option A:* Stroke with Burnt Sienna starting at the outside edge and pulling toward the center. (Fig. 5) While the Burnt Sienna is wet, pick up Warm White. Overstroke the Burnt Sienna. (Fig. 6) You will see the Burnt Sienna bleed through the white. Let the petals dry.

 Option B: Undercoat daisy petals with Warm White. Let dry.
3. Moisten a few petals at a time with blending medium.
4. Add a touches of Burnt Sienna and/or Green Umber at the center of each petal. Add Green Umber to the edges of some petals. (Fig. 7)
5. Blend, stroking toward the center. (Fig. 8)

Continued on next page

continued from page 53

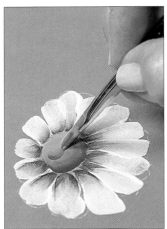

11. Using a smaller flat brush sideloaded with Burnt Sienna to paint a U-stroke in the daisy center. The daisy centers for the "Spring Surprise" daisies are done like this.

12. Sideloading the same (dirty) brush with Warm White.

Daisy Centers:

See the Daisies Worksheet, Figs. 6 through 10.

1. Undercoat with two or three coats Yellow Light. (Fig. 6) Let dry.
2. Apply blending medium.
3. Apply Yellow Light to the center. Add Burnt Sienna to shade. (Fig. 8) Blend. (Fig. 9)
4. Add floats of Green Umber to deepen the shadows. (Fig. 9)

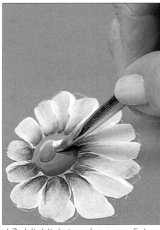

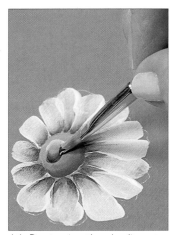

13. Highlighting the top of the indention.

14. Deepening the shading at the center of the indention with Burnt Umber.

5. Add water to Burnt Umber, Titanium White, and Red Light to create a very thin consistency of each color. Using a #1 liner, apply dots around the center with Burnt Umber. Then add a few dots of Titanium White and just a few of Red Light. (Fig. 10)

Note: These centers do not have an indention as those shown in step-by-step photos.

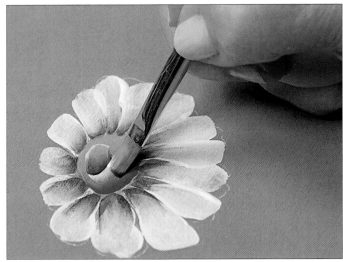

15. Floating Warm White under the indention.

Turned Daisy & Calyx:

See the Daisies Worksheet, Figs. 2, 3, and 4.

1. Apply blending medium, then Asphaltum and Green Umber. (Fig. 1)
2. While the colors are wet, neatly overstroke with Warm White. (Fig. 2)
3. Undercoat the bracts with Green Medium. Let dry thoroughly. (Fig. 3)
4. Float a shadow of Green Umber at the base of the calyx. (Fig. 3)
5. Shade the dark side of the calyx and stem with Green Umber. (Fig. 4)
6. Highlight the light side of the calyx with Warm White. (Fig. 4)
7. Float shadows of Green Umber and Asphaltum at the base of the petals around the calyx. (Fig. 4)

Stems:

1. Paint the stems with Green Medium.
2. Shade the dark sides with Green Umber.
3. Highlight with Titanium White. Let dry.

FINISHING

Apply one coat of finish. ❏

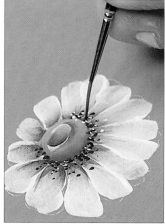

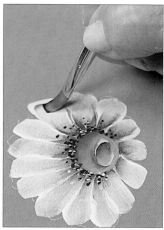

19. Using a liner brush to add just a few dots of thinned Red Light around the center.

20. Turning the edge of a petal by floating Burnt Umber in a scalloped U-stroke.

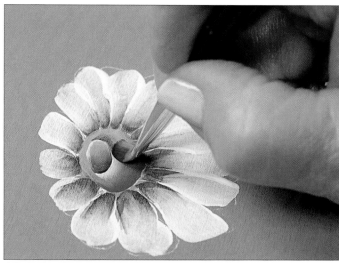

16. Adding Burnt Umber shading. The daisy centers here are painted as instructed for the "Spring Surprise" project on page 60.

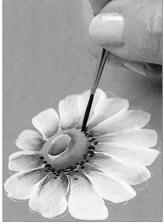

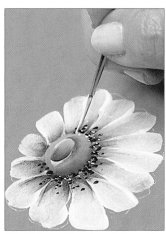

17. Using a liner brush to add dots of thinned Burnt Umber around the center.

18. Using a liner brush to add dots of thinned Warm White around the center.

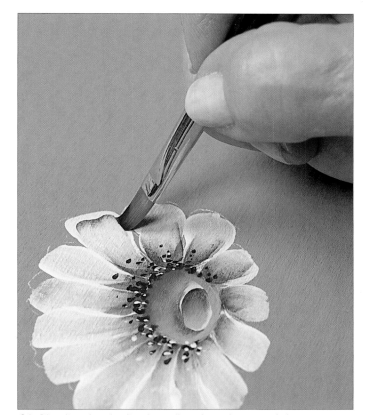

21. Blending the shading by pulling the color toward the center.

Daisies Worksheet

Fig. 1 – Paint shadow leaves first, then work from back to front. Paint the daisies that are in the back (underneath other flowers) before painting the daisies in the front of the design.

Fig. 2 – Apply blending medium. Apply colors.

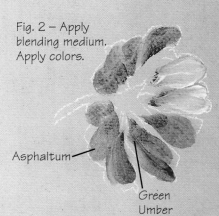

Asphaltum

Green Umber

Fig. 3 – While paint is still wet, overstroke petals with Warm White. Undercoat calyx with Green Medium. Let dry. Float shading on bracts and stem with Green Umber. Highlight with Warm White.

Fig. 4 – Float Green Umber and Asphaltum shadows on petals next to calyx to shade.

Daisies Worksheet

Fig. 5 – Apply blending medium. Option: Undercoat petals with Burnt Sienna.

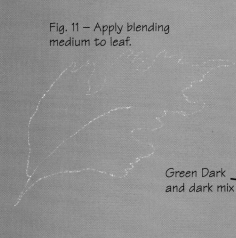

Fig. 6: Stroke petals with Warm White. Undercoat center with Yellow Light.

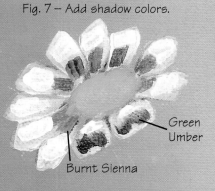

Fig. 7 – Add shadow colors.

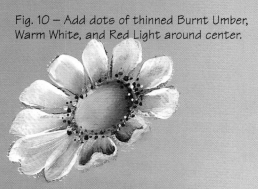

Green Umber

Burnt Sienna

Fig. 8 – Blend petals. Shade center with Burnt Sienna.

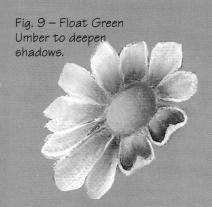

Fig. 9 – Float Green Umber to deepen shadows.

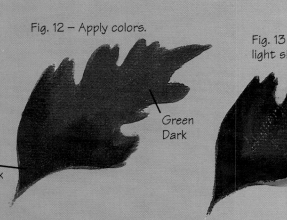

Fig. 10 – Add dots of thinned Burnt Umber, Warm White, and Red Light around center.

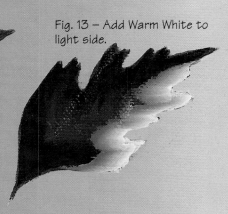

Fig. 11 – Apply blending medium to leaf.

Fig. 12 – Apply colors.

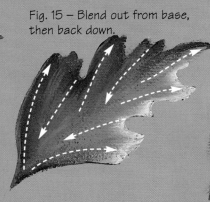

Green Dark

Green Dark and dark mix

Fig. 13 – Add Warm White to light side.

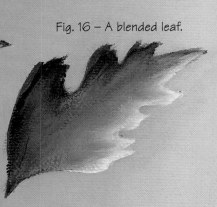

Fig. 14 – Add Green Medium and Warm White.

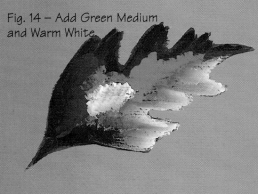

Fig. 15 – Blend out from base, then back down.

Fig. 16 – A blended leaf.

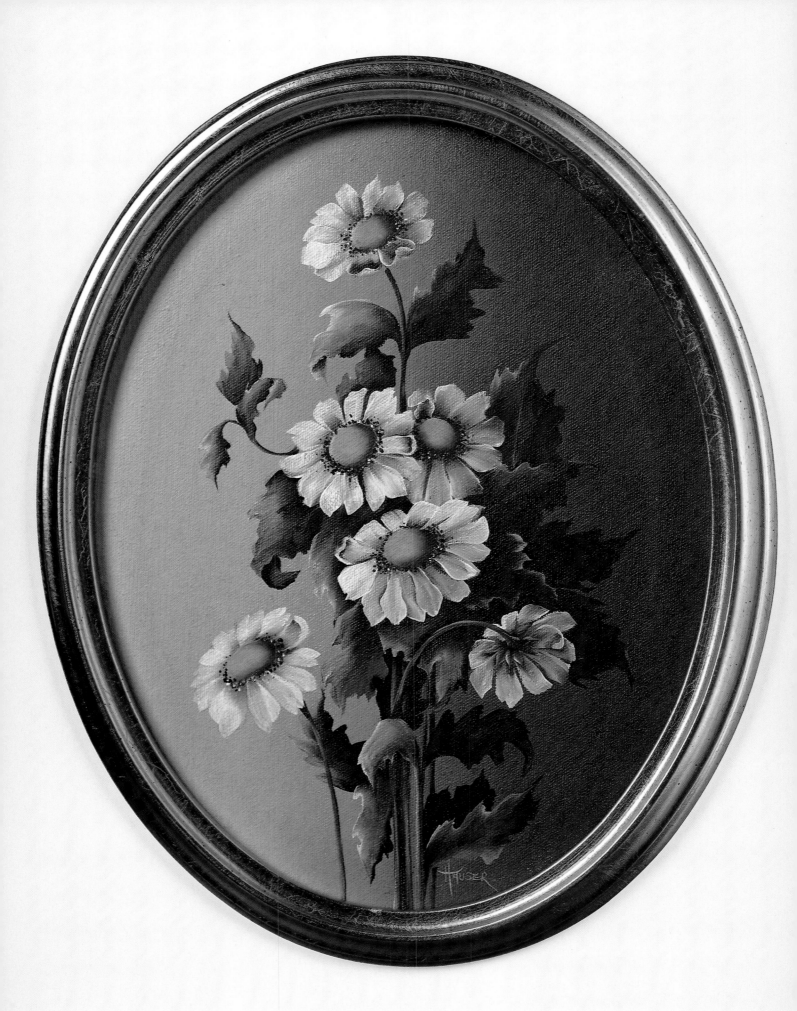

58

Pattern

Enlarge pattern @135% for actual size.

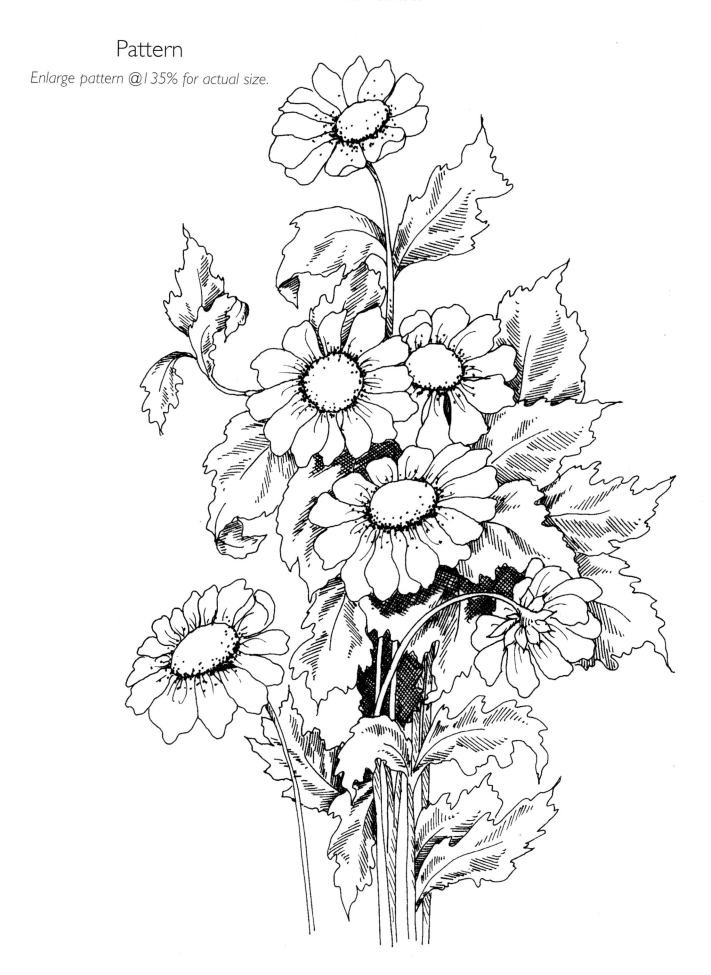

SPRING SURPRISE

This painting combines daisies, berries, and a bird's nest with eggs. The bird's nest is a wonderful surprise hidden under the daisies.

PALETTE OF COLORS

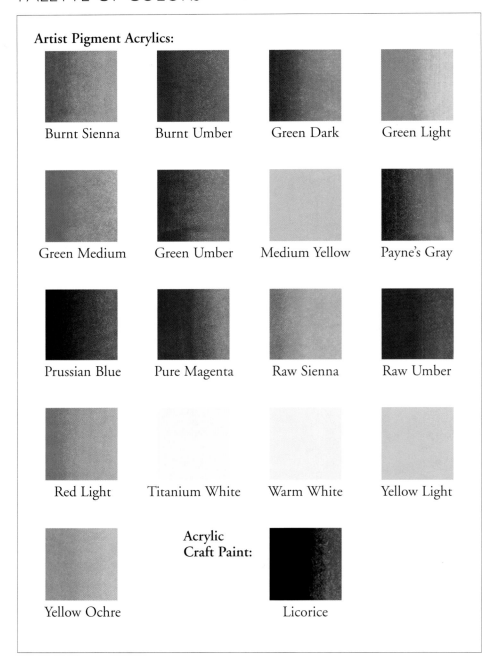

Artist Pigment Acrylics:

Burnt Sienna

Burnt Umber

Green Dark

Green Light

Green Medium

Green Umber

Medium Yellow

Payne's Gray

Prussian Blue

Pure Magenta

Raw Sienna

Raw Umber

Red Light

Titanium White

Warm White

Yellow Light

Yellow Ochre

Acrylic Craft Paint:

Licorice

SUPPLIES

Painting Surface:

Tempered pressed fiberboard (Masonite®), 16" x 24"

Brushes:

Shaders/Brights (flat) – #2, #4, #8, #10, #12, #14, #16

Liner – #1

Sponge brushes – 1", 2"

Medium:

Blending medium

Other Supplies:

Basic supplies listed on page 14.

PREPARATION

1. Wipe the surface with a tack cloth.
2. Paint with three coats Licorice. Let the paint dry between each coat.
3. When third coat is dry, rub with a piece of brown paper bag with no printing on it to smooth the surface.
4. Carefully trace the design on tracing paper.
5. Neatly and carefully transfer the design with white transfer paper.

PAINTING THE DESIGN

It will be easier if you paint from the back to the front of this design. Paint the objects furthermost back in the design and work toward the front.

Continued on page 62

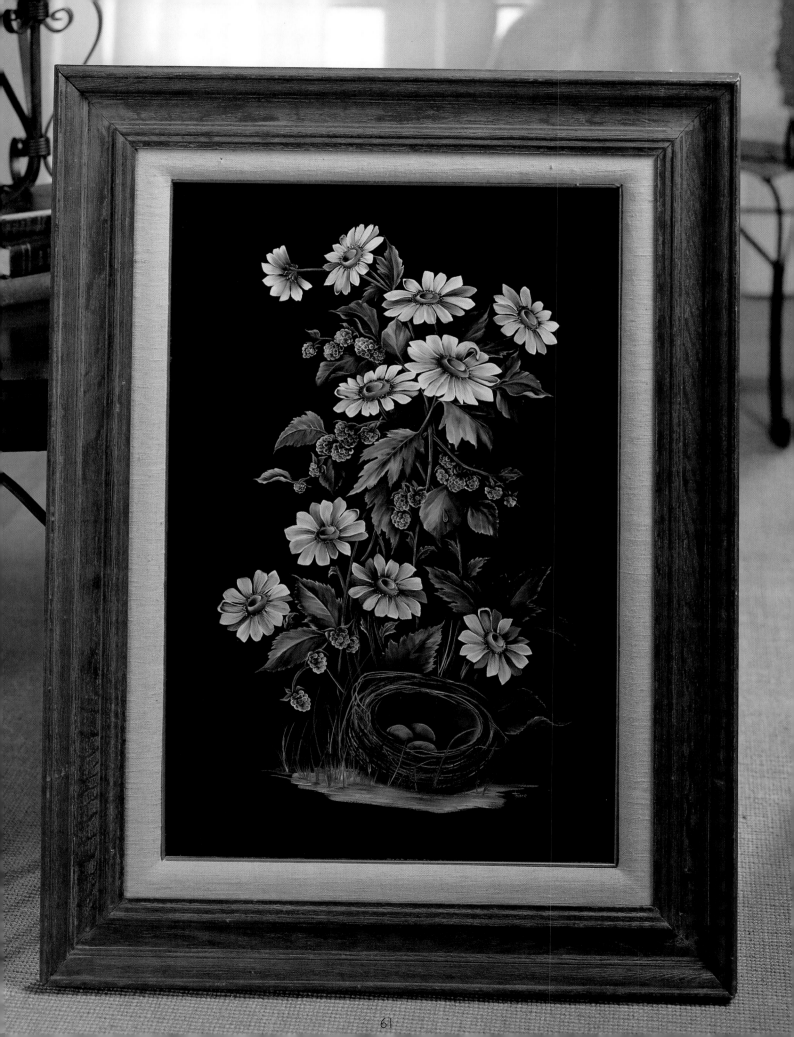

continued from page 60

Leaves:

These leaves may be painted with many different combinations of colors, using more Yellow Light, Green Light, or Green Dark or you may paint them exactly as shown on the Spring Surprise Worksheet, Figs. 14 through 16. The size of the brush you use depends on the size of the leaf.

1. *Option:* Undercoat the leaves with two or three coats of Green Dark, allowing the paint to dry between coats. (Often, when painting with acrylics, it is easier to cover if you undercoat first.)
2. Double load a brush with Green Dark and Warm White.
3. Using a scribbling motion (as you would with a pencil), scribble both sides of the leaf. The lightest color should be to the outside edge to contrast with the dark background. (Fig. 14)
4. Mix three parts Burnt Umber + one part Green Dark (3:1). Apply the shadow at the base of the leaf. Let dry.
5. Apply a small amount of blending medium all over the leaf. Reapply the dark mixture to the shadow area, then Green Light, then Yellow Light. (Fig. 14)
6. Wipe the brush and lightly pull or blend from the base of the leaf out toward the scribble strokes. (Fig. 15)
7. Lightly blend from the outside edges back toward the base of the leaf. Use a light touch. Use more paint or blending medium as needed. If you over-blend or "make mud," use a wipe-out tool or a cotton swab to remove the paint. Let the surface dry and start over.

Daisy – Back View:

See the Spring Surprise Worksheet, Figs. 11 through 13.

1. Using a medium-size flat brush, apply strokes of Warm White to create the individual petals. Let dry. (Fig. 11)
2. Undercoat the bracts and stem with Green Medium. Let dry. (Fig. 11)
3. Apply a tiny bit of blending medium to the petals, two or three at a time. Add more Warm White, and then shade them by floating on Green Umber. Let dry. (Fig. 12)
4. Float on just a touch of Burnt Sienna. Let dry. (Fig. 12)
5. Shade the base of the bracts with Burnt Umber. Let dry. (Fig. 11)
6. Highlight the edges of the bracts with Warm White. (Fig. 12)
7. Shade the dark side of the stem with Green Umber. Highlight on the light side with Warm White. (Fig. 12)
8. Blend bracts into stem. (Fig. 13)

Daisies – Front View:

See the Spring Surprise Worksheet, Figs. 1 through 7.

1. Stroke petals with Warm White. Undercoat the center with Warm White. Let dry. (Fig. 1)
2. Apply a second coat of Warm White, if desired. Let dry.
3. Using a flat brush, float Green Umber at the center of each petal. Add a tiny touch of Burnt Sienna, if desired. (Fig. 2)
4. To turn the edge of a petal, float a scalloped U-stroke just below the tip of the petal. (Fig. 3)
5. Paint the center with Yellow Light. (Fig. 4)
6. Shade with a double loaded brush (Yellow Light and Burnt Sienna) or a float of Burnt Sienna. Let dry. (Fig. 5)
7. Using a #4 flat brush, paint a sideways U-stroke in the upper portion of the center. Let dry. (Fig. 5)
8. Deepen the stroke with Burnt Umber. (Fig. 6)
9. Using a small brush double loaded with blending medium and Warm White, float another sideways U-stroke on the opposite side that joins the ends of the first. Let dry. (Fig. 6)
10. Float Burnt Umber under the white edge. (Fig. 6)
11. Float Warm White under the dark edge on the left side. Let dry. (Fig. 7)
12. Using the liner brush and very thin paint, neatly and carefully apply dots of Burnt Umber, Red Light, and Titanium White. (Fig. 7, Fig. 3)

Berries:

See the Spring Surprise Worksheet, Figs. 8 through 10, and the photo series "How to Paint Berries" that follows these project instructions.

1. Undercoat with Warm White. Let dry.
2. Apply the colors – Green Medium, Pure Magenta, Prussian Blue, and a yellow-green mix (equal amounts Green Light and Yellow Light), using a #1 or #2 flat brush. Let dry. (Fig. 8)
3. Apply a little blending medium, then carefully reapply the colors.
4. Dip the brush in blending medium and sideload with Warm White. Paint half-circles around the outside edge of the berry. Go back and fill in with three-quarter circles and a few whole circles. Let dry.
5. Paint the bracts with Green Medium. (Fig. 8)
6. Shade bracts with Burnt Umber. (Fig. 9)
7. Highlight bracts with Titanium White. (Fig. 10)
8. Highlight berries here and there, using a #1 liner brush with thinned Titanium White.

Bird's Nest & Eggs:

See the Bird's Nest & Eggs Worksheet.

1. Undercoat the nest with Burnt Umber. (Fig. 1)
2. Mix Titanium White + a touch of Burnt Umber + a touch of Prussian Blue (5:1:1) to make ice blue. Neatly and carefully undercoat the eggs with the ice blue mix. Let dry. (Fig. 2)
3. Apply a little blending medium to the nest. Thin Burnt Umber, Raw Umber, Raw Sienna, and Warm White to the consistency of ink. Using your liner brush, weave fine lines to create the straw look of the nest. Work neatly and carefully. It will take some time to build a really pretty nest. (Figs. 1 through 5)
4. Working one egg at a time, apply a little blending medium to the eggs.
5. Shade the eggs with Payne's Gray. Blend the color into the blending medium. Let dry. (Fig. 4)
6. Float a tiny bit of Burnt Umber on the eggs. (Fig. 5)
7. Add more "straw" to the nest, using your liner brush and the various thinned colors.

Grass:

1. Using a large flat brush, float Green Umber around the nest. Let dry.
2. Apply a second float of Green Umber. Let dry.
3. Mix Green Umber and Warm White (2:1). Using a back-and-forth stroking motion, paint the ground under the nest.
4. Shade the darkest part (next to the nest) with Green Umber and blend into a lighter shade of green as you move forward. Let dry.
5. Apply blending medium and reapply colors – Green Umber, the mix, and a tiny bit of Warm White. Merge the colors, as shown in the project photograph.
6. Using the flat edge of your flat brush, pull up the blades of grass using Green Umber, the mix, and highlights of Warm White. Paint many blades of grass coming from a common (same) spot for a natural look.

FINISHING

1. Allow the painting to dry and cure for a couple of weeks.
2. Apply a final coat of finish. ❏

How to Paint Berries

This photo series shows how to paint berries, step by step.

1. Undercoat berry area with White.

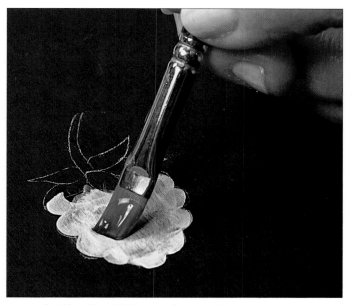

2. Apply Blending Gel to undercoated area.

Continued on next page

continued from page 63

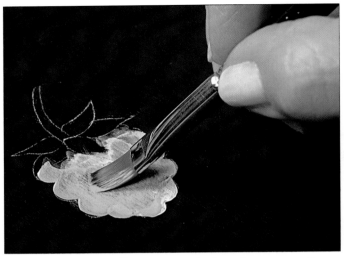

3. Roughly paint yellow-green mix (equal amounts Green Light and Yellow Light) on one side of berry.

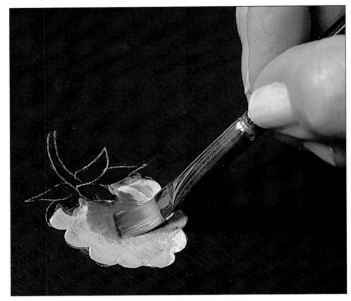

4. Paint Pure Magenta on other side of berry.

5. Dip brush in Prussian Blue.

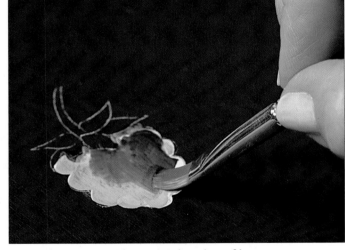

6. Apply Prussian Blue on right edge of berry.

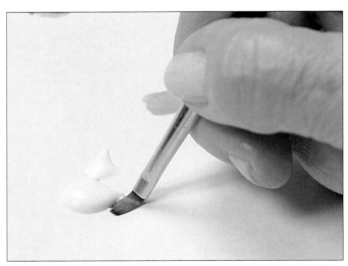

7. Dip the brush in blending medium. Load Warm White on one side.

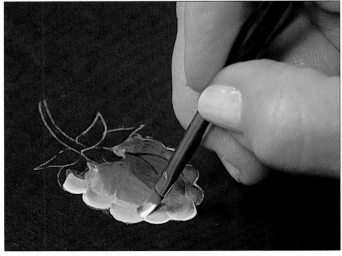

8. Paint half-circle strokes around edge of berry.

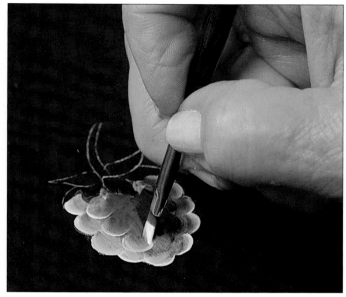

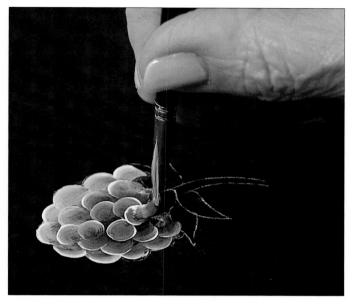

9. Using same brush, paint more half circles and some three-quarter circles on the berry. Reload brush with Warm White as needed.

10. Finish berry by making a few white circle strokes.

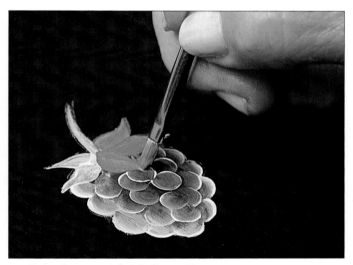

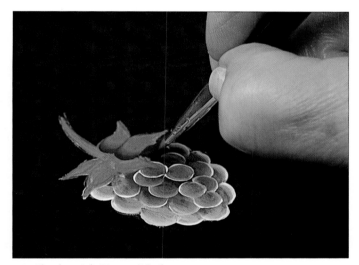

11. Paint bracts with Medium Green.

12. Shade with Burnt Umber.

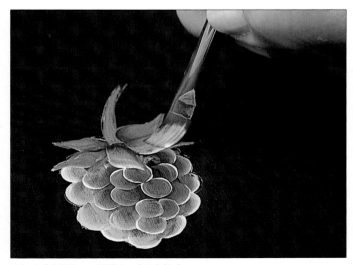

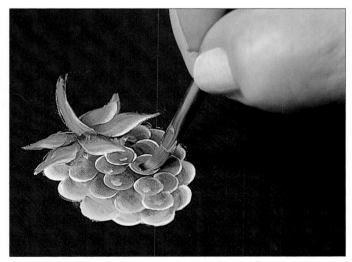

13. Add Warm White highlights.

14. Using a #1 liner brush, add a few small dots of Warm White to the berry to highlight.

Spring Surprise Worksheet

Daisies

Fig. 1 – Stroke petals with Warm White. Let dry. Undercoat the center with Warm White. Let dry.

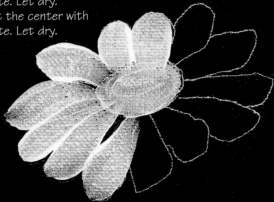

Fig. 2 – Float Green Umber around center. *Option:* Add a tiny touch of Burnt Sienna.

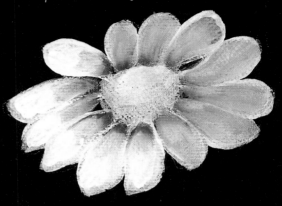

Fig. 3 – A finished daisy. To turn the petal edge, float a scalloped U-stroke just below the tip.

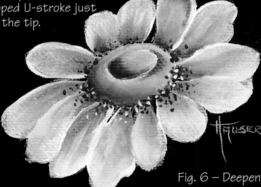

Fig. 4 – Paint the center with Yellow Light.

Fig. 5 – Shade with a double loaded brush (Yellow Light and Burnt Sienna) or a float of Burnt Sienna. Using a #4 flat brush, paint a sideways U-stroke in the upper portion of the center. Let dry.

Fig. 6 – Deepen the stroke with Burnt Umber. Using a small brush double loaded with blending medium and Warm White, float another sideways U-stroke on the opposite side. Float Burnt Umber under the white edge.

Fig. 7 – Float Warm White under the dark edge on the left side. Let dry. Add dots of Burnt Umber, Red Light, Titanium White.

Berries

Fig. 8 – Apply colors. Let dry. Apply blending medium. Re-apply colors.

Green Medium

Pure Magenta

Prussian Blue

Yellow-green mix (Green Light + Yellow Light)

Fig. 9 – Dip the brush in blending medium. Sideload with Warm White. Paint half-circles around the outside edge of the berry. Fill in with three-quarter circles and a few whole circles. Shade bracts with Burnt Umber. Let dry.

Fig. 10 – Highlight bracts with Titanium White. Highlight berries here and there with thinned Titanium White.

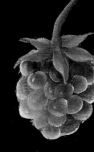

Spring Surprise Worksheet

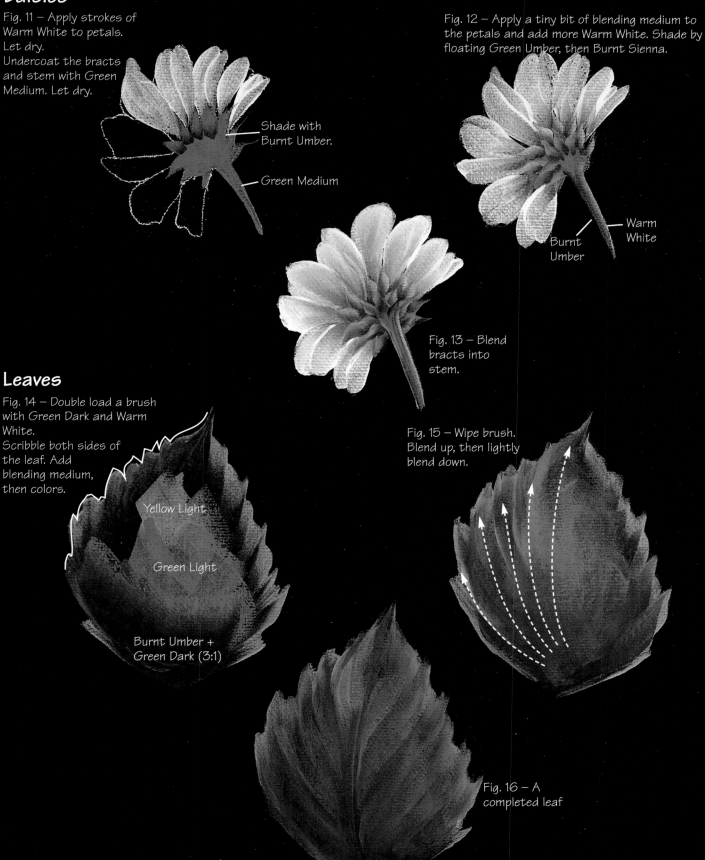

Daisies

Fig. 11 — Apply strokes of Warm White to petals. Let dry.
Undercoat the bracts and stem with Green Medium. Let dry.

Shade with Burnt Umber.

Green Medium

Fig. 12 — Apply a tiny bit of blending medium to the petals and add more Warm White. Shade by floating Green Umber, then Burnt Sienna.

Warm White

Burnt Umber

Fig. 13 — Blend bracts into stem.

Leaves

Fig. 14 — Double load a brush with Green Dark and Warm White.
Scribble both sides of the leaf. Add blending medium, then colors.

Yellow Light

Green Light

Burnt Umber + Green Dark (3:1)

Fig. 15 — Wipe brush. Blend up, then lightly blend down.

Fig. 16 — A completed leaf

Bird's Nest & Eggs Worksheet

Fig. 1 – Undercoat the nest with Burnt Umber.

Fig. 2 – Undercoat eggs with the ice blue mix. Let dry.

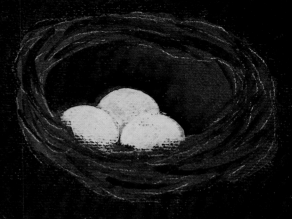

Fig. 3 – Working one egg at a time, apply a little blending medium to the eggs. Shade eggs with Payne's Gray.

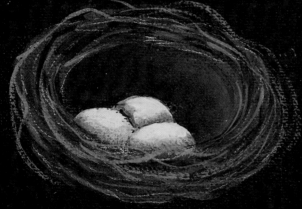

Fig. 4 – Blend the color into the blending medium. Let dry.

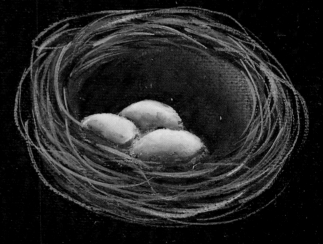

Fig. 5 – Float a tiny bit of Burnt Umber on the eggs.

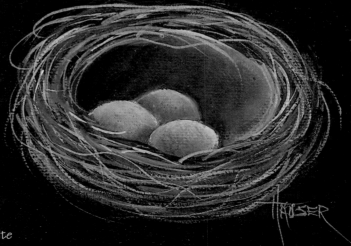

To paint the nest: After undercoating, apply a blending medium. Using a liner brush, weave fine lines of Burnt Umber, Raw Umber, Raw Sienna, and Warm White to create the look of straw.

Pattern

Enlarge pattern @240% for actual size.

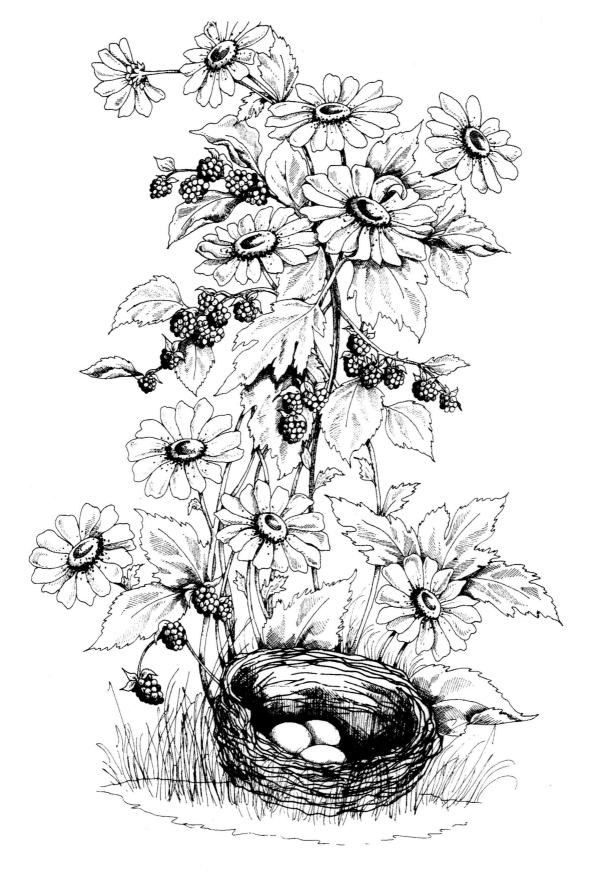

DAFFODILS PORTRAIT

One signal that Spring has arrived is the appearance of daffodils (jonquils).
There are so many varieties, and they can be painted in a multitude of yellows,
whites, and (even) gentle greens.

PALETTE OF COLORS

Artist Pigment Acrylics:

Green Dark | Green Light | Green Medium | Yellow Light

Medium Yellow | Burnt Sienna | Pure Orange | Titanium White

Burnt Umber | Green Umber | Warm White | Raw Umber

Prussian Blue

SUPPLIES

Painting Surface:
Canvas oval, 11" x 14"

Brushes:
Flats – #4, #8, #10, #12, #14
Liner – #1

Medium:
Blending medium

Other Supplies:
Oval frame
plus the basic supplies listed on
page 14.

Instructions begin on page 72

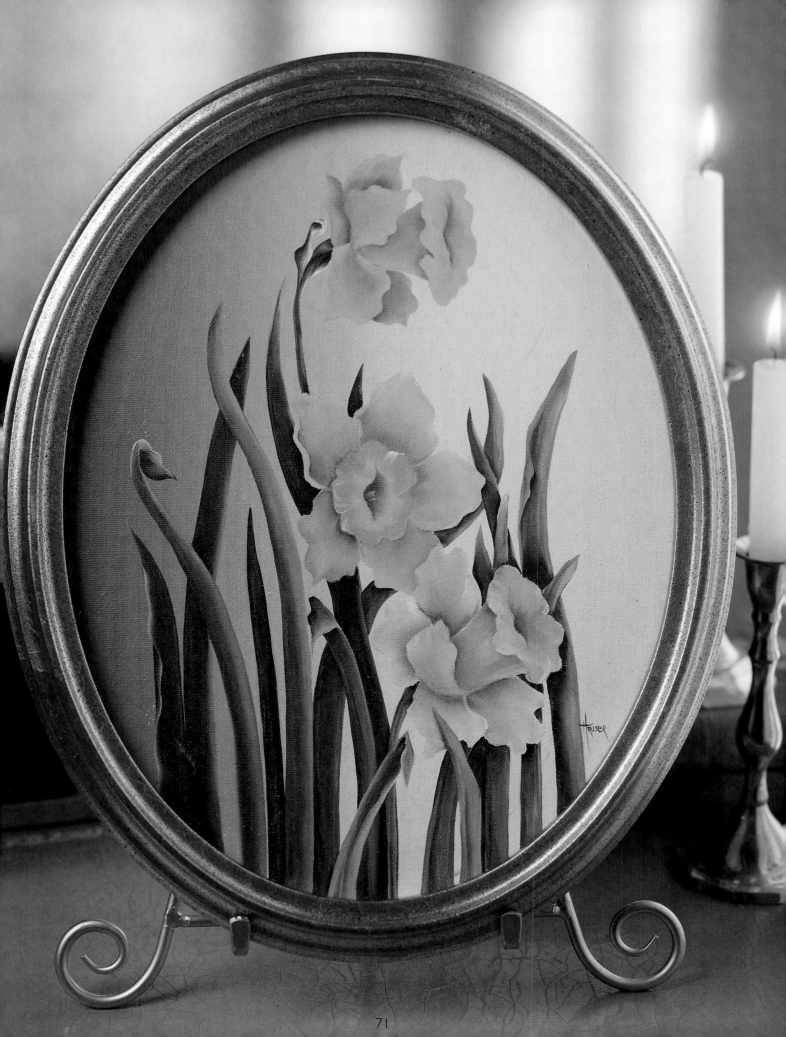

continued from page 70

PREPARATION

1. Lightly sand the canvas with fine grade sandpaper.
2. Wipe any dust away with a tack cloth.
3. Lightly dampen the canvas with water. Water must not stand or puddle on the canvas, but the canvas should be wet.
4. Create a dark green mix by combining Green Umber + a touch of Raw Umber.
5. Using the sponge brush, apply the dark green mix to approximately one-fourth of the canvas.
6. Using a clean sponge brush, apply Titanium White on the remaining portion of the canvas.
7. While the paint is wet, quickly wipe your brush and blend the light into the dark. Wipe the brush frequently and then blend the dark into the light. You want a lovely graduated background from dark to medium to light. Let dry.
8. Neatly trace and transfer the design.

2 Applying Blending Gel.

1. Shading the undercoated flower.

PAINTING THE DESIGN

See the Daffodils Worksheet, Fig. 1, before you start to paint. Begin with the leaves that are the furthermost back in the design. Paint one leaf at a time.

Shadow Leaves:

See the Shadow Leaf Worksheet.

1. Undercoat shadow leaves with a mixture of Burnt Umber + Burnt Sienna (1:1). Let dry.
2. Apply a small amount of blending medium to the leaves.
3. Paint the leaves with the Burnt Umber/Burnt Sienna mixture.
4. Highlight with Warm White.

Dark Blended Leaves:

1. Undercoat the dark leaves with Green Dark.
2. Shade the dark side of the leaf with a dark mix (Burnt Umber + a touch of Prussian Blue).
3. Highlight with Warm White. Blend.

Medium Blended Leaves:

See the Daffodils Worksheet, Figs. 8 through 10.

1. Undercoat with Green Medium. Let dry. (Fig. 8)
2. Apply blending medium. Apply the dark mix (Burnt Umber + a touch of Prussian Blue), Green Medium, and Green Light. (Fig. 9) Blend. (Fig. 10)
3. Highlight with Warm White. Blend.

Light Blended Leaves:

See the Daffodils Worksheet, Figs. 8 through 11.

1. Undercoat with Green Medium. Let dry. (Fig. 8)
2. Apply blending medium. Apply the dark mix (Burnt Umber + a touch of Prussian Blue), Green Medium, and Green Light. (Fig. 9) Blend. (Fig. 10)
3. Add Warm White. Blend. (Fig. 11)

Side View Daffodil:

It is important to paint just one petal at a time; otherwise, the paint will dry before you can finish blending. See the Daffodils Worksheet, Figs. 2 and 3.

1. Undercoat with two or more coats Yellow Light. Let dry. (Fig. 2)
2. Apply blending medium and colors (Medium Yellow, Pure Orange, Burnt Sienna, Green Umber, Warm White) to one petal at a time. Blend. (Fig. 2)
3. Carefully blend each petal, as well as the center. (Fig. 3)

Full Daffodil Flowers:

See the Daffodils Worksheet, Figs. 4 through 7.

1. Undercoat the flower with two or three coats of Yellow Light. Let dry. (Fig. 4)
2. Double-load a brush with Floating Medium on one side

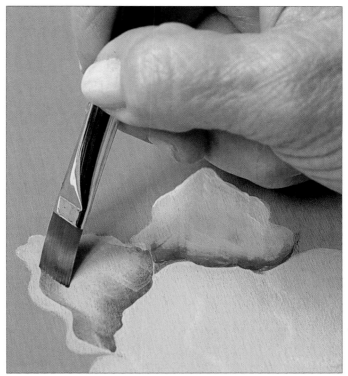

4. Shading under the turned edge of the petal.

and Burnt Sienna + a tiny touch of Burnt Umber on the other side. Float shadows at the base of each petal. Let dry. (Fig. 5)

3. Apply blending medium. Working one petal at a time, apply colors to the petals (Titanium White, Yellow Light, Burnt Sienna + Burnt Umber, Pure Orange). Wipe the brush and pat and blend each petal. (Fig. 5)
4. Apply blending medium to the center. Apply Pure Orange and pull from the outside edge toward the center. (Fig. 6)
5. Paint the very center of the flower with an S-stroke, using a small brush double loaded with Yellow Light and the Burnt Sienna-Burnt Umber mix. Let dry. (Fig. 7)
6. Highlight the center with Warm White. Let dry. (Fig. 7)

FINISHING

Apply one coat of finish. ❏

3. Applying colors (Titanium White, Yellow Light, Burnt Sienna + Burnt Umber, Pure Orange).

Daffodils Worksheet

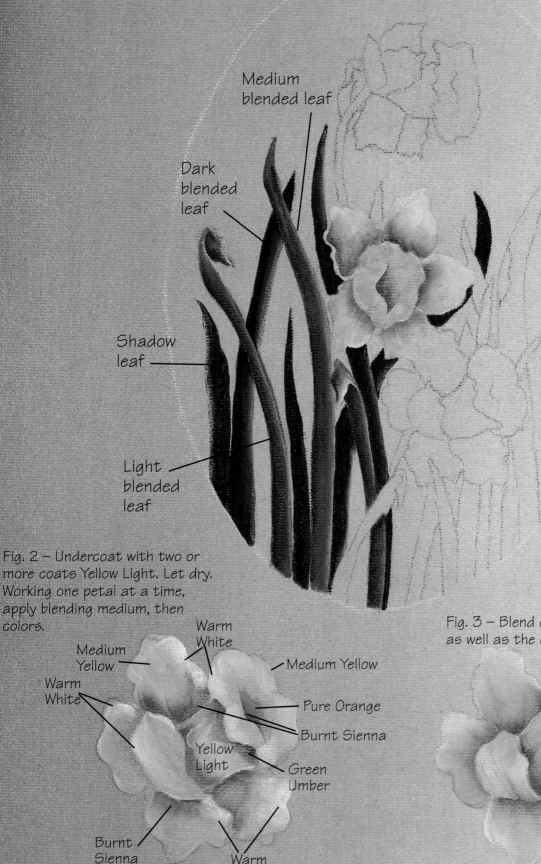

Medium blended leaf

Dark blended leaf

Shadow leaf

Light blended leaf

Fig. 1 – Paint shadow leaves first, then the remaining leaves, working dark to light, back to front.

Paint the back daffodil before painting the top daffodil, then paint the top leaf.

Fig. 2 – Undercoat with two or more coats Yellow Light. Let dry. Working one petal at a time, apply blending medium, then colors.

Warm White

Medium Yellow

Warm White

Medium Yellow

Pure Orange

Burnt Sienna

Yellow Light

Green Umber

Burnt Sienna

Warm White

Fig. 3 – Blend each petal, as well as the center.

Daffodils Worksheet

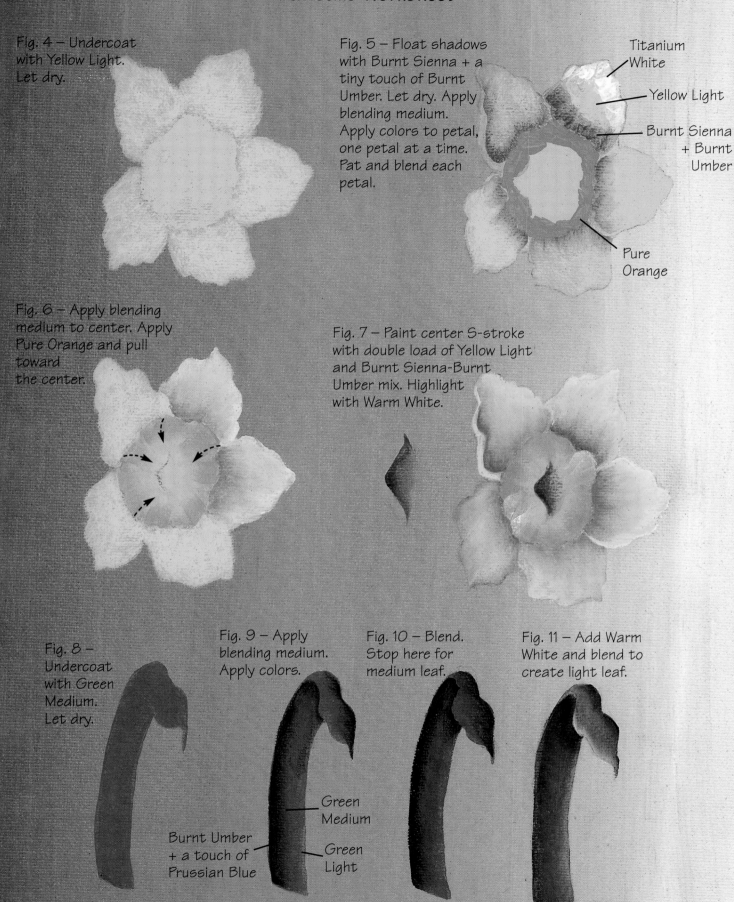

Fig. 4 – Undercoat with Yellow Light. Let dry.

Fig. 5 – Float shadows with Burnt Sienna + a tiny touch of Burnt Umber. Let dry. Apply blending medium. Apply colors to petal, one petal at a time. Pat and blend each petal.

Titanium White

Yellow Light

Burnt Sienna + Burnt Umber

Pure Orange

Fig. 6 – Apply blending medium to center. Apply Pure Orange and pull toward the center.

Fig. 7 – Paint center S-stroke with double load of Yellow Light and Burnt Sienna-Burnt Umber mix. Highlight with Warm White.

Fig. 8 – Undercoat with Green Medium. Let dry.

Fig. 9 – Apply blending medium. Apply colors.

Fig. 10 – Blend. Stop here for medium leaf.

Fig. 11 – Add Warm White and blend to create light leaf.

Burnt Umber + a touch of Prussian Blue

Green Medium

Green Light

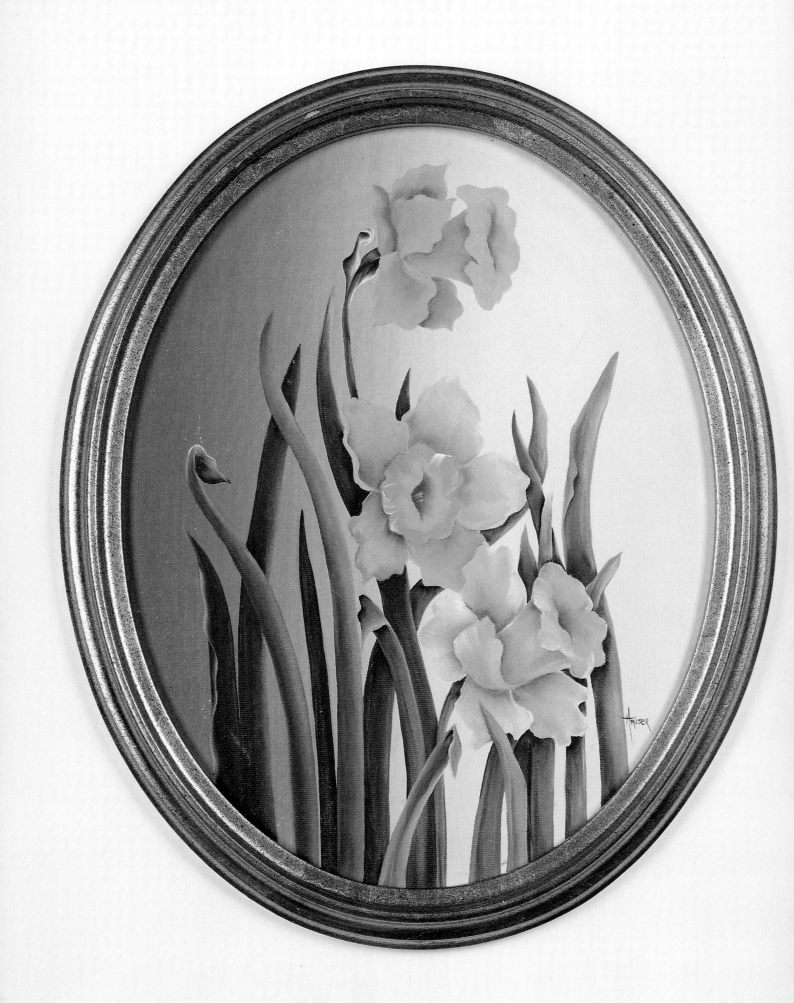

Pattern

Enlarge pattern @135% for actual size.

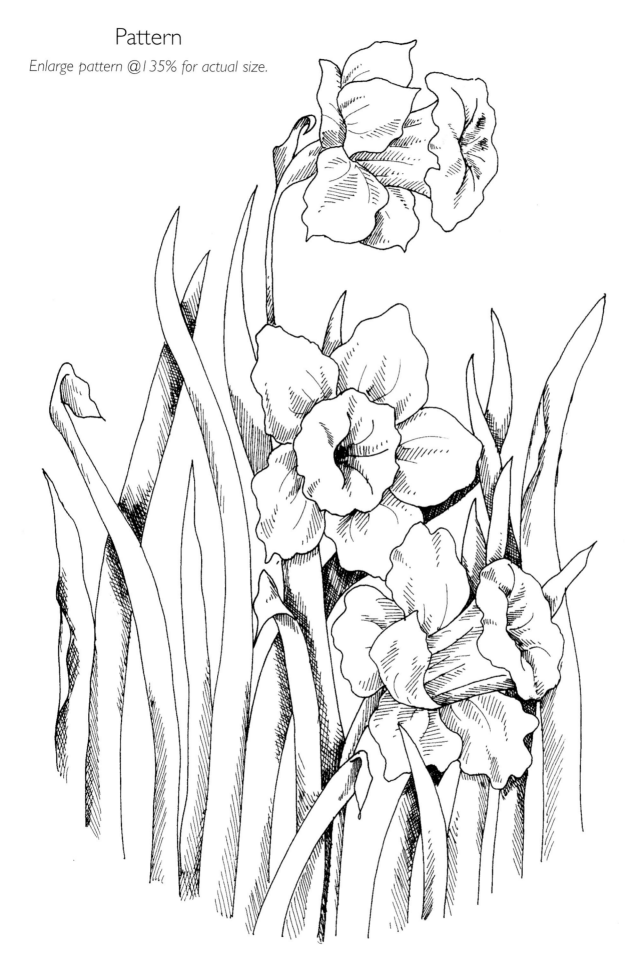

POPPIES PORTRAIT

Pretty poppies come in every color imaginable.
Their petals are so delicate, soft, and transparent.

PALETTE OF COLORS

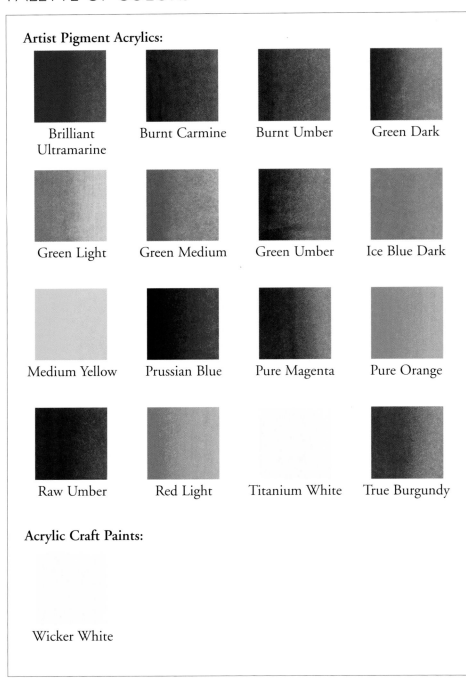

Artist Pigment Acrylics:

Brilliant Ultramarine

Burnt Carmine

Burnt Umber

Green Dark

Green Light

Green Medium

Green Umber

Ice Blue Dark

Medium Yellow

Prussian Blue

Pure Magenta

Pure Orange

Raw Umber

Red Light

Titanium White

True Burgundy

Acrylic Craft Paints:

Wicker White

SUPPLIES

Painting Surface:
Canvas oval, 11" x 14"

Brushes:
Flats – #4, #8, #10, #12, #14
Liner – #1
Beat-up, worn brush for scruffy painting
Sponge brushes – 1", 2"

Medium:
Blending medium

Other Supplies:
Oval frame
plus basic supplies listed on page 14.

PREPARATION

1. Lightly sand the canvas with fine grade sandpaper.
2. Wipe any dust away with a tack cloth.
3. Lightly dampen the canvas with water. Water must not stand or puddle on the canvas, but the canvas should be wet.
4. Using the sponge brush, apply Raw Umber to approximately one-fourth of the canvas.
5. Using a clean sponge brush, apply Wicker White to the remainder of the canvas.

Continued on page 80

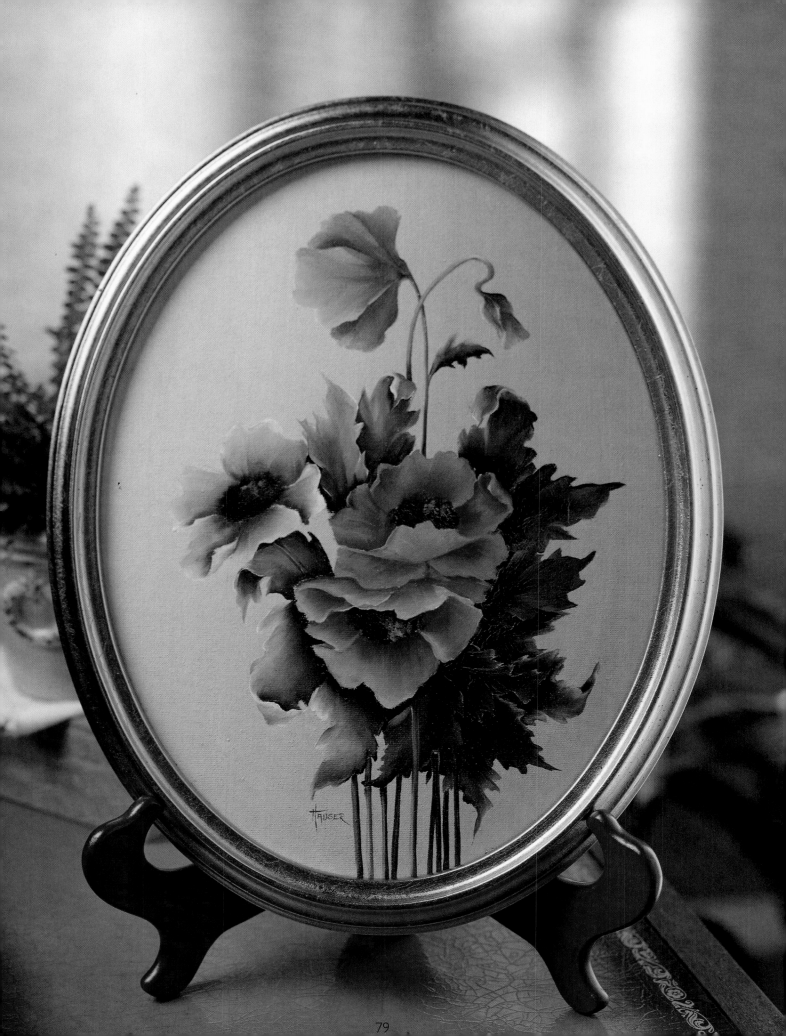

continued from page 78

6. Quickly wipe your brush and, while the paint is wet, blend the light into the dark. Wipe the brush frequently and then blend the dark into the light. You want a lovely graduated background from dark to medium to light. Let the canvas dry.

7. Neatly trace and transfer the design.

PAINTING THE DESIGN

Begin with the leaves that are the furthermost back in the design.

Leaf Undercoats:

1. Undercoat the shadow leaves with Burnt Sienna. Two or three coats will be needed to cover. Let the paint dry thoroughly between the coats.

2. Undercoat the dark leaves with Green Dark. Apply two or three coats and allow to dry between applications.

3. Undercoat the medium value leaves with Green Medium. Apply two or three coats and allow to dry between applications.

4. Undercoat the light value leaves with Green Light. Apply two or three coats and allow to dry between applications.

Shadow Leaves:

1. Working one leaf at a time, apply a small amount of blending medium to the leaf.

2. Mix Prussian Blue + Burnt Umber (1:4) to make a dark

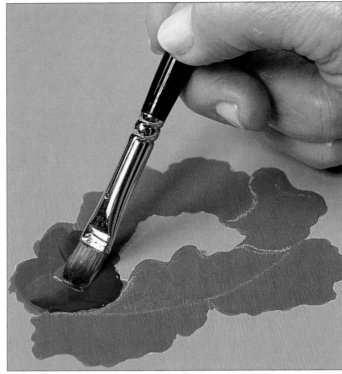

2. Adding colors to areas of the petal.

mix. Float a dark shadow at the base of the leaf and where it goes underneath other leaves or flowers. Let dry.

3. Use a small amount of Ice Blue Dark + Titanium White to highlight the edge. (The shadow leaves stay very dark.)

Dark Value Leaves:

1. Working one leaf at a time, apply a small amount of blending medium to the leaf.

2. Double load your brush with Green Dark and the dark mix. "Scribble" neatly and slowly back and forth, with the dark edge of the brush on the outside, to create the rough edge on the leaf.

3. Wipe the brush. Double load with Green Dark and Titanium White. Blend on the palette to soften the color.

4. Turn the leaf upside down and scribble on the light side of the leaf with the light color to the outside edge.

5. Add Warm White and Green Light to the center of the leaf. Wipe the brush and blend from the base of the leaf out toward the edges of the leaf. Lightly blend back toward the base. Use a light touch.

6. Highlight with Warm White.

7. *Option:* Lightly vein the leaf with the dark mix.

Medium Value Leaves:

Paint as you painted the Dark Value Leaves, substituting Green Medium for Green Dark.

1. Applying blending medium to an undercoated poppy.

Light Value Leaves:
Paint as you painted the Dark Value Leaves, substituting Green Light for Green Dark.

Flower Petals:
See the Poppies Worksheet.
1. Undercoat petals of open poppies with two or three coats Red Light and Pure Orange. See the Worksheet for color placement. Let dry. (Figs. 2 and 5)
2. Apply blending medium to a few petals at a time. Float Pure Orange on the edges. Let dry. (Fig. 5)
3. Float Burnt Carmine in the shadow areas. (Fig. 2) Let dry.
4. Working one petal at a time, apply blending medium and colors (Burnt Carmine, Pure Orange, True Burgundy, Red Light, Medium Yellow, Warm White). (Figs. 3 and 6)
5. Wipe the brush. Pat and blend the dark into the light and the light into the dark. Add more blending medium or more color, if needed. (Figs. 4 and 7)

Flower Centers:
See the Poppies Worksheet, Fig. 8.)
1. Using a beat-up, worn brush, carefully stipple (dab) Burnt Umber in the center.
2. Highlight with just a little Pure Orange, Brilliant Ultramarine + Titanium White (2:1) and a tiny bit of

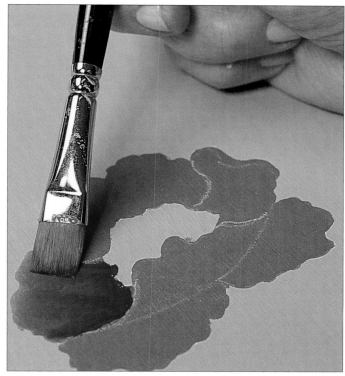

4. Continuing to blend.

Pure Magenta lightened with Titanium White (2:1).
3. Using your liner brush with thinned paint, apply a few dots of Burnt Umber and Pure Orange on the petals.

Poppy Bud:
See the Poppies Worksheet.
1. Float Burnt Carmine shadows on all the petals. Let dry. (Fig. 9)
2. Working one petal at a time, apply blending medium and colors shown. (Fig. 9)
3. Wipe the brush and blend. Use a light touch. Add more blending medium or colors, as desired. (Fig. 10)

Stems:
See the Poppies Worksheet.
1. Paint with Green Medium. (Figs. 2 and 9)
2. Shade the dark side with Green Dark and Green Umber. (Figs. 3 and 9)
3. Highlight with Warm White. (Figs. 4 and 9) Let dry.

FINISHING
Apply one coat of finish. ❑

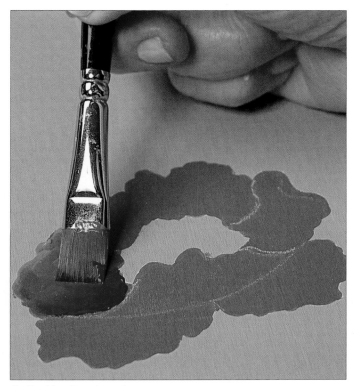

3. Pat blending the colors.

Poppies Worksheet

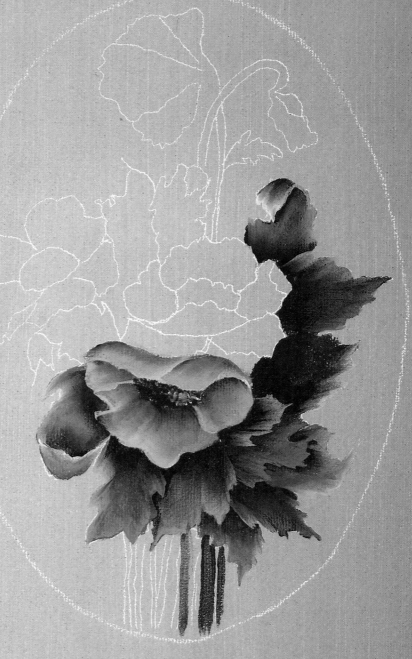

Fig. 1 – Work from the back of the design to the front, painting shadow petals first. On the poppy shown here, paint the center before you paint the top two petals.

Fig. 2 – Undercoat with Pure Orange. Let dry. Float Burnt Carmine shadows. Paint stem with Green Medium.

Fig. 3 – Add colors. Shade stem with Green Umber.

Warm White

Pure Orange

Burnt Carmine

Medium Yellow

Red Light

True Burgundy

Fig. 4 – Blend one petal at a time. Highlight stem with Warm White.

Poppies Worksheet

Fig. 5 – Undercoat open petals of open poppies with Pure Orange and Red Light. Let dry.

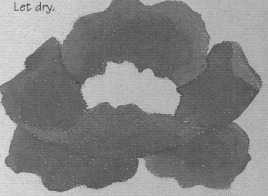

Fig. 6 – Apply blending medium. Apply colors, working one petal at a time.

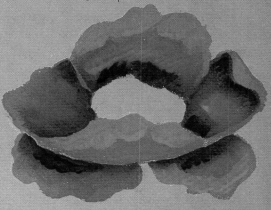

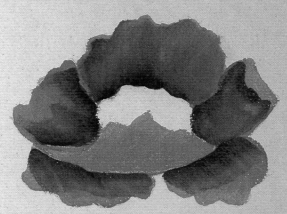

Fig. 7 – Pat and blend dark into light and light into dark. Add more blending medium or paint, if needed.

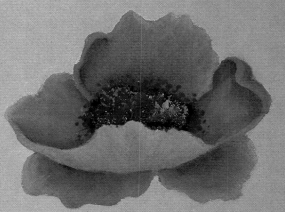

Fig. 8 – (Stipple (dab) the center with Burnt Umber, using an old brush. Highlight with Brilliant Ultramarine + Titanium White and Pure Magenta + Titanium White. Apply dots of Brilliant Ultramarine and Pure Orange.

Fig. 9 – Apply blending medium. Apply colors.

Fig. 10 – Blend.

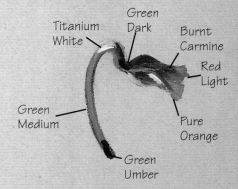

Titanium White

Green Dark

Burnt Carmine

Red Light

Green Medium

Pure Orange

Green Umber

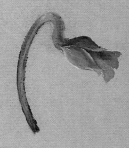

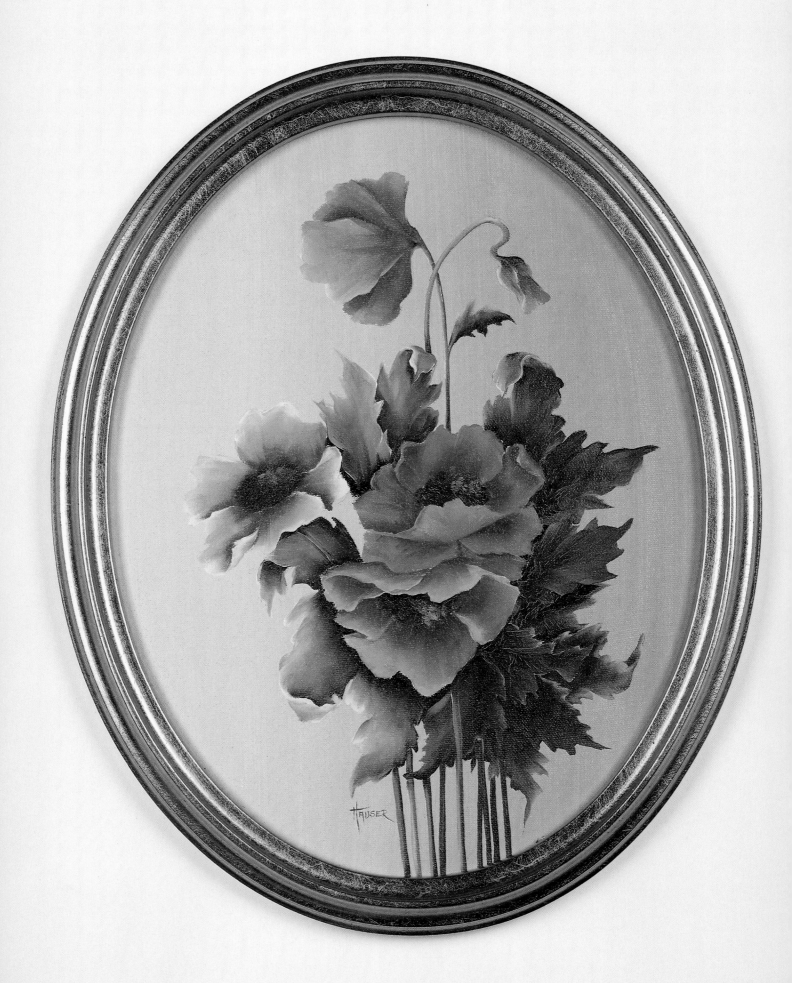

84

Pattern
Enlarge pattern @135% for actual size.

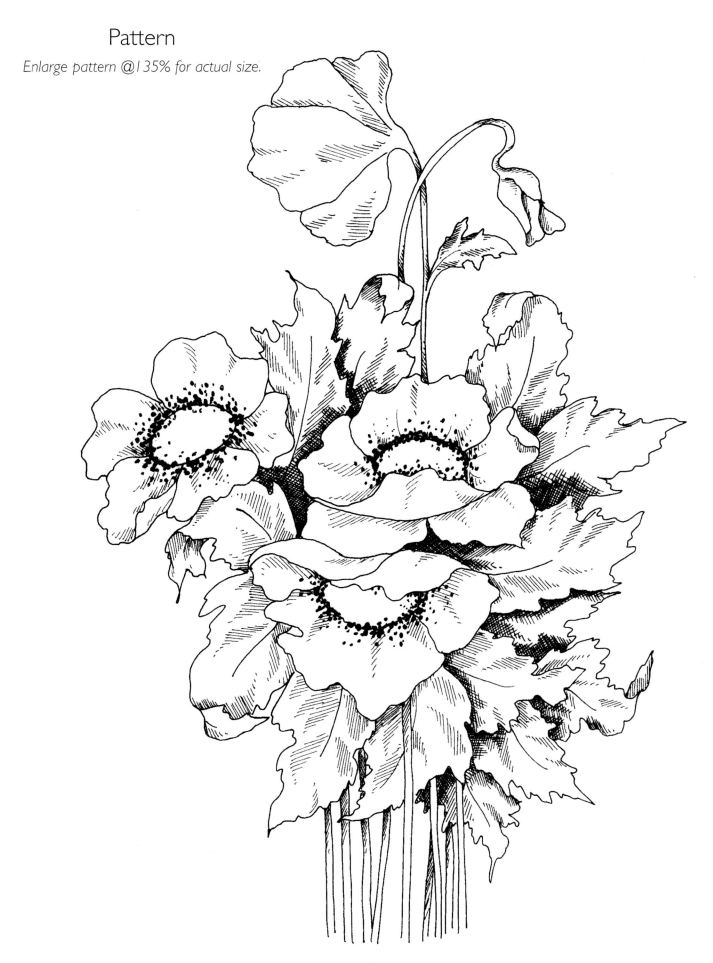

SUNFLOWERS PORTRAIT

Appropriately named and almost as brilliant as their namesake, sunflowers bring delight and warmth to our lives. You cannot help but smile as you paint their glowing faces. This portrait is sure to brighten any spot in which you choose to display it.

PALETTE OF COLORS

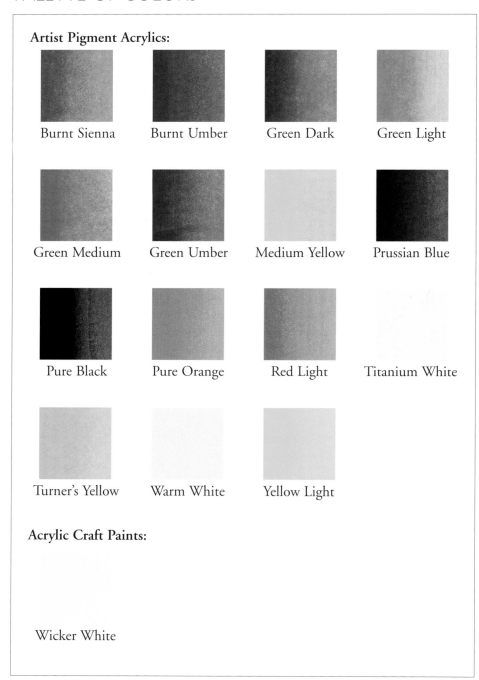

Artist Pigment Acrylics:

Burnt Sienna Burnt Umber Green Dark Green Light

Green Medium Green Umber Medium Yellow Prussian Blue

Pure Black Pure Orange Red Light Titanium White

Turner's Yellow Warm White Yellow Light

Acrylic Craft Paints:

Wicker White

SUPPLIES

Painting Surface:
Canvas oval, 11" x 14"

Brushes:
Flats – #4, #8, #10, #12, #14
Liner – #1
Old beat-up scruffy brush
Sponge brushes – 1", 2"

Mediums:
Blending medium
Floating medium

Other Supplies:
Oval frame
plus the basic supplies listed on page 14.

PREPARATION

1. Lightly sand the canvas with fine grade sandpaper.
2. Wipe any dust away with a tack cloth.
3. Lightly dampen the canvas with water. Water must not stand or puddle on the canvas, but the canvas should be wet.
4. Using the sponge brush, apply the Pure Black to approximately one-eighth of the canvas.
5. Using a clean sponge brush, apply Wicker White to the remainder of the canvas.

Continued on page 88

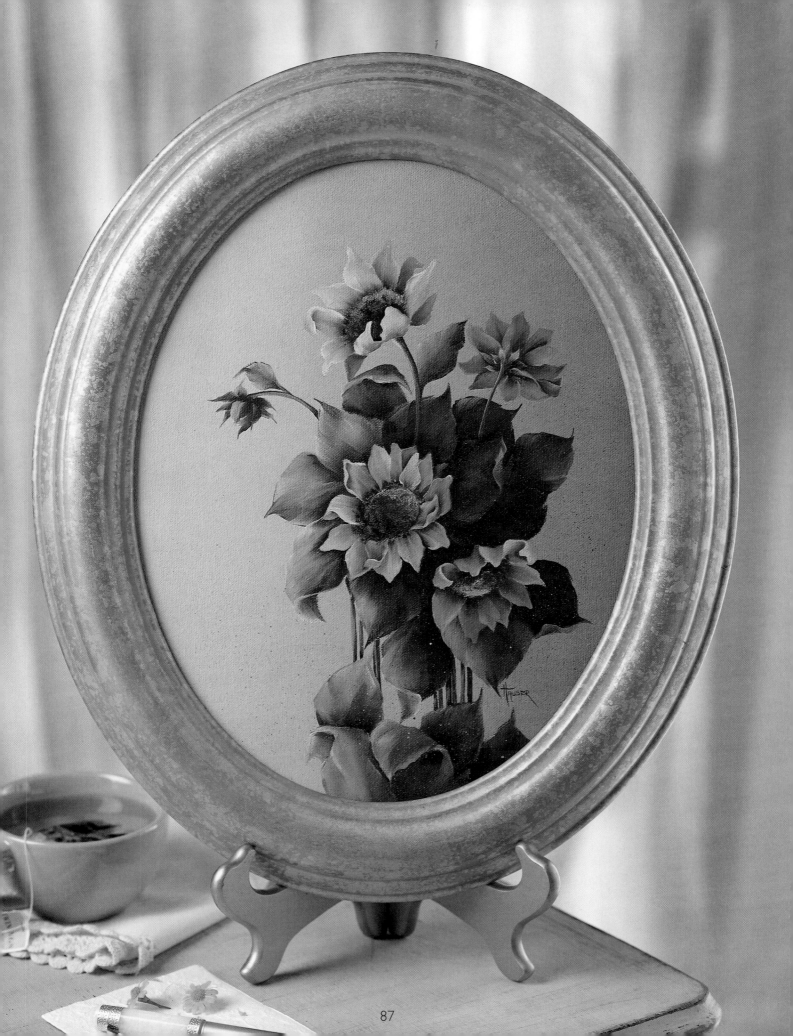

continued from page 86

6. Quickly wipe your brush and, while the paint is wet, blend the light into the dark. Wipe the brush frequently, and then blend the dark into the light. You want a lovely graduated background from dark to medium to light. Let the canvas dry.

7. Neatly trace and transfer the design.

PAINTING THE DESIGN

Shadow Leaves:

1. Undercoat with Burnt Sienna.
2. Shade with Burnt Umber + Green Umber (1:1).
3. Highlight with Warm White.

Blended Leaves:

See the Sunflowers Worksheet.

1. Undercoat with Green Medium. Let dry.
2. Shade the base of the leaf with Burnt Umber. (Fig. 8)
3. Apply blending medium. Add colors (Green Light, Burnt Umber, Warm White, Green Medium). (Fig. 9)
4. Blend lightly. (Fig. 10)

Sunflower Petals:

See the Sunflowers Worksheet.

1. Undercoat with two or three coats Yellow Light. Let dry. (Fig. 5)
2. Using a double-loaded brush with floating medium on one side and Burnt Sienna + a tiny touch of Burnt Umber on the other, float shadows at the base of each petal. Let dry. (Fig. 5)
3. Working one petal at a time, apply blending medium and colors. (Warm White, Turner's Yellow, Burnt Sienna, Medium Yellow). (Fig. 6)
4. Wipe the brush and pat and blend each petal. (Fig. 7)

Sunflower Bud & Calyx:

See the Sunflowers Worksheet.

1. Undercoat the petals with Yellow Light. Let dry.
2. Undercoat the calyx with Green Medium. Let dry. (Fig. 2)
3. Shade the bud with a float of Burnt Sienna. (Fig. 2)
4. Shade the calyx with a float of Burnt Umber. (Fig. 3)
5. Highlight the calyx with floats of Warm White. (Fig. 4)

Sunflower Centers:

1. Using an old, worn brush, dab Burnt Umber in the center. (Fig. 6)
2. Highlight with just a little Pure Orange, then Prussian Blue + Warm White, and finally Red Light. (Fig. 7)
3. Deepen the shadow on the petals with Burnt Umber, if necessary. Let dry. (Fig. 7)

FINISHING

Apply one coat of finish. ❑

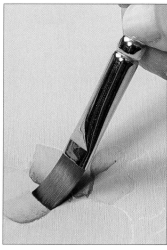

1. Shading the base of an undercoated petal with Burnt Sienna.

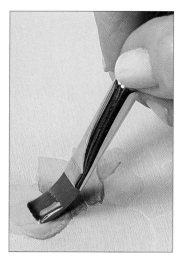

2. Applying blending medium.

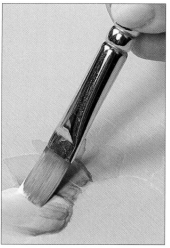

3. Applying colors to the petal.

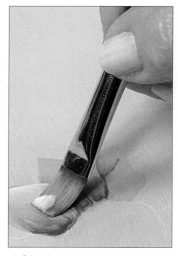

4. Blending.

Pattern

Enlarge pattern @140% for actual size.

Sunflowers Worksheet

Fig. 1 – Paint shadow leaves first.

Work from the back to the front of the design, using the numbers as a guide.

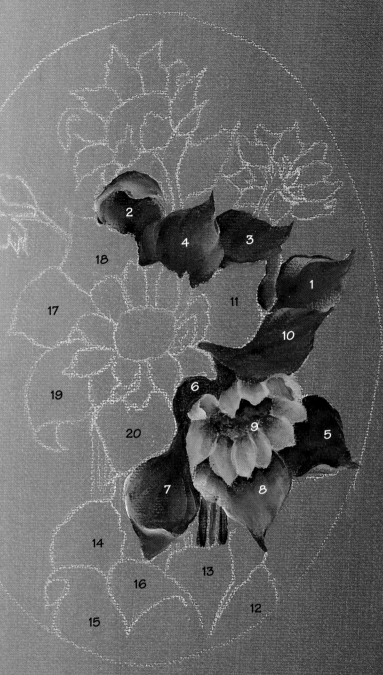

Fig. 2 – Undercoat and shade.

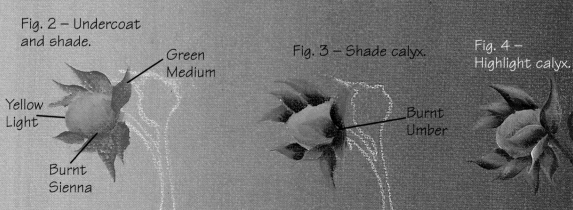

Green Medium

Yellow Light

Burnt Sienna

Fig. 3 – Shade calyx.

Burnt Umber

Fig. 4 – Highlight calyx.

Warm White

Sunflowers Worksheet

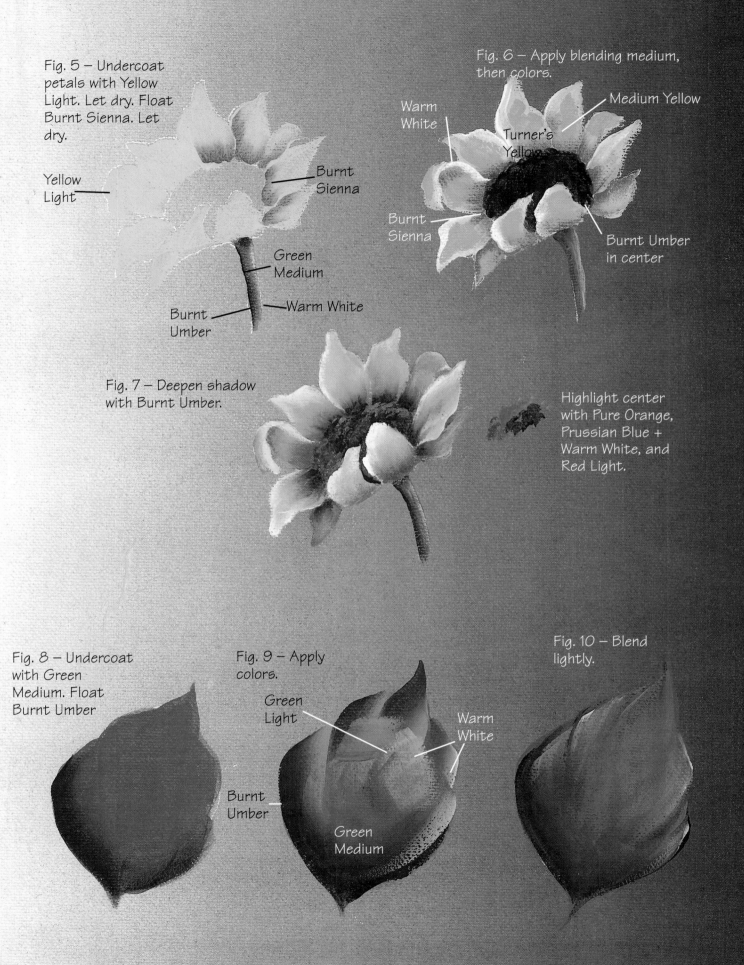

Fig. 5 – Undercoat petals with Yellow Light. Let dry. Float Burnt Sienna. Let dry.

Yellow Light

Burnt Sienna

Green Medium

Burnt Umber

Warm White

Fig. 6 – Apply blending medium, then colors.

Warm White

Medium Yellow

Turner's Yellow

Burnt Sienna

Burnt Umber in center

Fig. 7 – Deepen shadow with Burnt Umber.

Highlight center with Pure Orange, Prussian Blue + Warm White, and Red Light.

Fig. 8 – Undercoat with Green Medium. Float Burnt Umber

Fig. 9 – Apply colors.

Green Light

Warm White

Burnt Umber

Green Medium

Fig. 10 – Blend lightly.

Sunflowers Basket

Here's a more casual idea for a sunflower painting – adding a bouquet of sunflowers to the bottom panel of a circular basket. The painting has a dramatic black background and the undercoating is done with pure gold metallic paint.

PALETTE OF COLORS

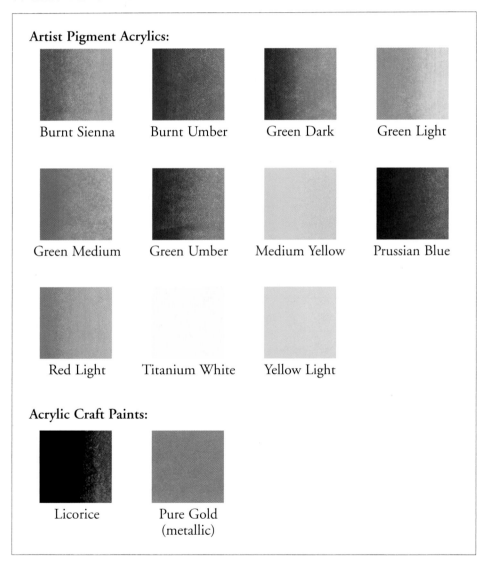

Artist Pigment Acrylics:

Burnt Sienna Burnt Umber Green Dark Green Light

Green Medium Green Umber Medium Yellow Prussian Blue

Red Light Titanium White Yellow Light

Acrylic Craft Paints:

Licorice Pure Gold (metallic)

SUPPLIES

Painting Surface:
Basket with round bottom panel (Panel is 11-1/2" diameter)

Brushes:
Flats – #4, #8, #10, #12, #14
Liner – #1
Old beat-up scruffy brush
Sponge brushes – 1", 2"
Old toothbrush (for spattering)

Mediums:
Blending medium
Floating medium
Glazing medium

Other Supplies:
Basic supplies listed on page 14.

Instructions begin on page 96

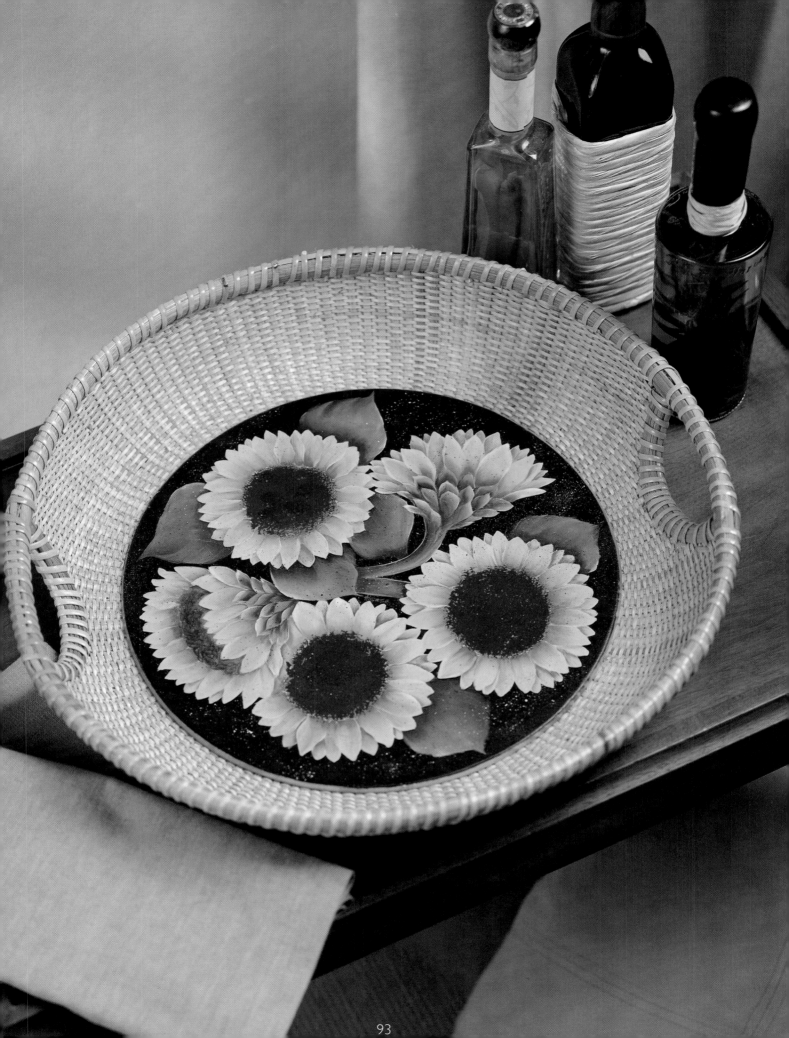

Sunflowers Basket Worksheet

Fig. 1 – Undercoat with Pure Gold. Let dry. Paint with two or more coats Yellow Light.

Fig. 3 – Apply blending medium to petals. Apply colors and blend. Stipple center with Burnt Umber, letting some of the gold show through. Overstroke the petal edges here and there with Titanium White + blending medium. Add a few dots of thinned Titanium White. Wash petals with Medium Yellow.

Fig. 2 – Float shading around center with Red Light and Burnt Sienna. Float Burnt Sienna shading on back petals. Float Green Umber to separate and shade some petals.

Fig. 6 – Double load brush with Green Dark and Green Medium. Stroke the left side. Add Titanium White to the light side of the brush. Stroke the light side. Apply blending medium. Pick up Green Light and apply at center of leaf.

Fig. 4 – Undercoat leaf with Pure Gold. Let dry.

Fig. 5 – Undercoat with Green Dark. Float base of leaf with Burnt Umber + Prussian Blue.

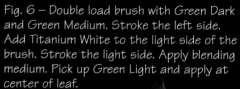

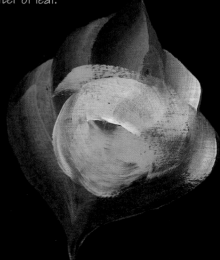

Sunflowers Basket Worksheet

Fig. 7 – Blend from the base up.

Fig. 8 – Blend from the outside edges back to the base.

Fig. 9 – Add more paint, if needed, and finish blending.

Fig. 10 – Undercoat with Pure Gold. Let dry. Paint petals with Yellow Light. Let dry.

Fig. 11 – Shade petals. Add colors to petals and blend. Float accent strokes with Titanium White on the edges of some petals. Base stem and calyx with Green dark. Float shading with Green Umber. Stroke on highlights with double-loaded Green Light and Titanium White. Blend.

Fig. 12 – The completed calyx.

HAUSER

continued from page 92

PREPARATION

1. Sand the insert to smooth it.
2. Wipe away dust with a tack cloth.
3. Paint the basket bottom with two to three coats Licorice. Let dry between coats.
4. Trace and carefully transfer the design.

PAINTING THE DESIGN

See the Sunflower Basket Worksheet.

Leaves:

1. Undercoat with Pure Gold. Let dry. (Fig. 4)
2. Paint with Green Dark. (Fig. 5)
3. Float base of leaf with Burnt Umber + Prussian Blue. (Fig. 5)
4. Double load brush with Green Dark and Green Medium. Stroke the left side of the leaf. Add Titanium White to the light side of the brush. Stroke the light side. (Fig. 6)
5. Apply blending medium. Pick up Green Light and apply at center of leaf. (Fig. 7)
6. Blend from the base up. (Fig. 7) Blend from the outside edges back to the base. (Fig. 8) Add more paint, if needed, and finish blending. (Fig. 9)

Open Sunflowers:

1. Undercoat with Pure Gold. Let dry. (Fig. 1)
2. Paint petals with two or more coats Yellow Light. (Fig. 1)
3. Float Burnt Sienna shading on back petals. (Fig. 2)
4. Float shading around center with Red Light and Burnt Sienna. (Fig. 2)
5. Float Green Umber to separate and shade some petals. (Fig. 2)

6. Apply blending medium to petals. Apply colors (Yellow Light, Red Light, Medium Yellow, Burnt Sienna) and blend. (Fig. 3)
7. Stipple center with Burnt Umber, letting some of the gold show through. (Fig. 3)
8. Overstroke the petal edges here and there with Titanium White + blending medium. (Fig. 3)
9. Add a few dots of thinned Titanium White. (Fig. 3)
10. Wash petals with Medium Yellow. (Fig. 3)

Side View Sunflowers & Buds:

1. Undercoat flower and calyx with Pure Gold. Let dry. (Fig. 10)
2. Paint petals with Yellow Light. Let dry. (Fig. 10)
3. Shade petals with floats of Burnt Sienna. (Fig. 11)
4. Add colors to petals (Yellow Light, Red Light, Medium Yellow, Burnt Sienna) and blend. (Fig. 11)
5. Float accent strokes with Titanium White on the edges of some petals. (Fig. 11)
6. Base stem and calyx with Green Dark. (Fig. 11)
7. Float shading with Green Umber. (Fig. 11)
8. Stroke on highlights with double-loaded Green Light and Titanium White. (Fig. 11) Blend. (Fig. 12) Let dry.

FINISHING

1. Add glazing medium to Burnt Sienna and mix with a palette knife to a thin consistency. Flyspeck the sunflowers. See the Basic Information section for instructions on Flyspecking.
2. Add glazing medium to Titanium White, mix, and flyspeck around the edges of the design. Let dry completely.
3. Apply two or more coats of finish over the painting. ❏

Pattern

Enlarge pattern @135% for actual size.

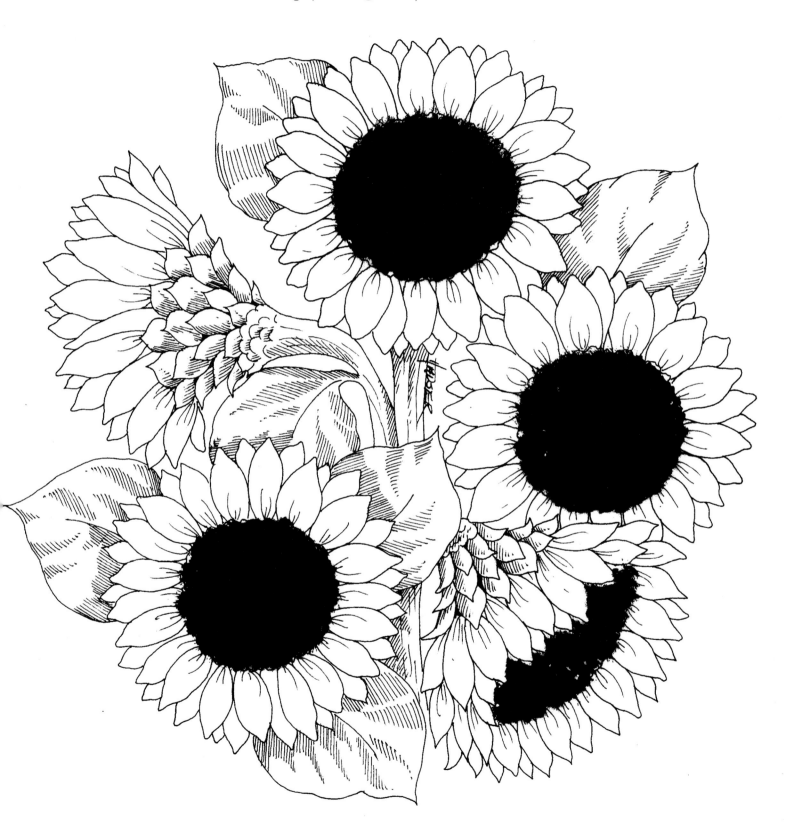

LILIES OF THE VALLEY PORTRAIT

I found this white frame that looks like an old-fashioned window and thought it was just the thing to accent these lilies of the valley with their tiny white bell-shaped flowers. The frame came with a distressed white finish, so it needed little preparation.

PALETTE OF COLORS

Artist Pigment Acrylics:

Green Dark · Green Light · Green Umber · Ice Green Light

Titanium White · Yellow Citron

SUPPLIES

Painting Surface:

Oval "window frame" frame, 9-1/2" x 14"

Oval pressed fiberboard insert, 6-1/2" x 11"

Brushes:

Liner – #1

Shaders/Brights (flats) – #6, #8, #10, #12

Filbert – #4

Wash/Glaze – 1" flat

Sponge brush – 2"

Other Supplies:

Gesso

Sea sponge

Matte sealer spray

plus the basic supplies listed on page 14.

PREPARATION

1. Generally, pieces you buy with a distressed finish are waxed instead of varnished. When that's the case (as it is here), all you have to do is sand the frame with fine grade sandpaper just enough to remove the wax.
2. Wipe with a tack cloth. Spray with a matte sealer.
3. Trace and transfer the ribbon design using gray graphite paper.
4. Prepare the insert with two coats of gesso, using the 2" sponge brush. Let dry.
5. Dampen a sea sponge and squeeze out excess water. Sponge with Green Umber, then Green Light, keeping it lighter at the outside edges. Allow to dry and cure.
6. Trace and transfer the leaves, using white transfer paper.

Continued on page 100

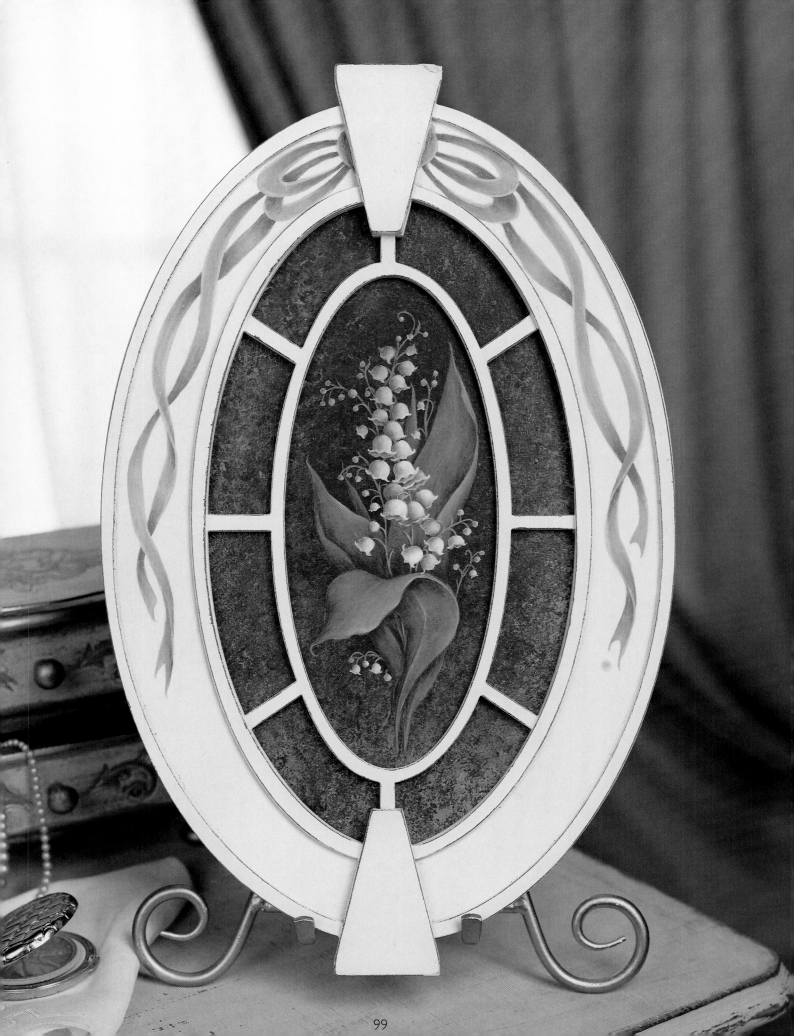

Continued from page 98

1. Floating a Green Umber shadow.

PAINTING THE DESIGN

See the Lilies of the Valley Worksheet.

Leaves:

1. Undercoat the leaves with two coats of Green Light. Let dry and cure. (Fig. 1)
2. Using a #10 or #12 flat brush, shade the leaves with a Green Umber float across the base and under the turns. Let dry. (Fig. 1)
3. Float on Green Dark accents. (Fig. 2)
4. Highlight the right sides of the forward leaves and the turns with floats of Yellow Citron. (Fig. 2)
5. On some right sides and turns, add additional highlights with Ice Green Light floats. (Fig. 3)

Flowers:

1. Transfer the flowers, buds, and stems, using white transfer paper.
2. Undercoat the lily of the valley and the buds, using a #4 filbert brush and two coats of Ice Green Light. Let dry and cure. (Fig. 4)
3. Shade the left sides and the bottom with Green Umber floats. Let dry. (Fig. 4)

4. Accent the right sides with Yellow Citron floats. Let dry. (Fig. 5)
5. With a liner brush and Titanium White, paint a ruffle across the bottom and the little turned up sides. (Fig. 6)
6. Lighten the right sides of the flowers with Titanium White floats. (Fig. 7)
7. If the ruffle is raised on the flower, shade just below the ruffle as needed with floats of Green Umber. (Fig. 7)

Buds:

1. Shade the left sides of the undercoated buds with Green Umber floats. (Fig. 4)
2. Highlight the buds on the right with floats of Green Light. Let dry. (Fig. 5)
3. Add Titanium White floats on the right sides of some buds. (Fig. 7)

Stems:

1. Using the tip of the liner brush with thinned Green Light, paint the stems. (Fig. 4)
2. Highlight the stems where needed with Ice Green Light. (Fig. 7)

Instructions continued on page 102

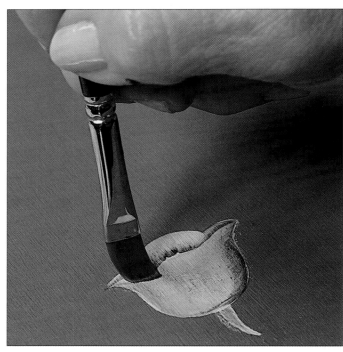

2. Accenting with a float of Yellow Citron.

Lilies of the Valley Worksheet

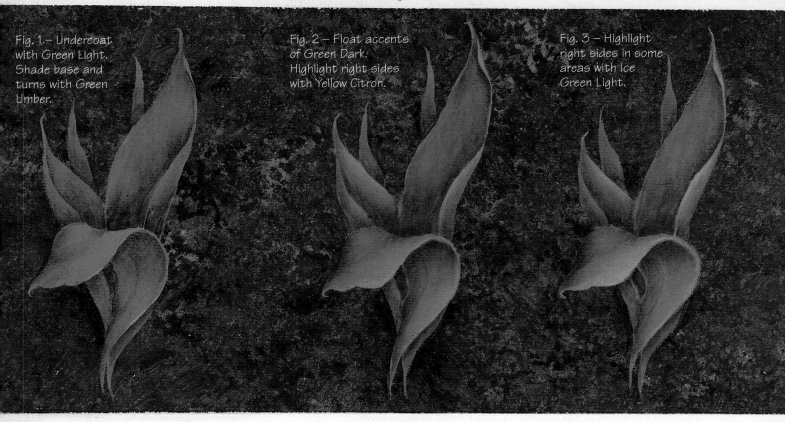

Fig. 1.– Undercoat with Green Light. Shade base and turns with Green Umber.

Fig. 2 – Float accents of Green Dark. Highlight right sides with Yellow Citron.

Fig. 3 – Highlight right sides in some areas with Ice Green Light.

Fig. 4 – Paint stems with Green Light. Undercoat flowers and buds with Ice Green Light. Shade left sides with Green Umber.

Fig. 5 – Accent right sides of flowers with Yellow Citron.

Fig. 6 – Add "ruffles" with Titanium White.

Fig. 7 – Highlight stems with Ice Green Light. Highlight right sides of flowers with Titanium White.

Fig. 8 – Undercoat ribbon with Green Light. Shade with Green Umber. Accent with Green Dark. Highlight with Ice Green Light.

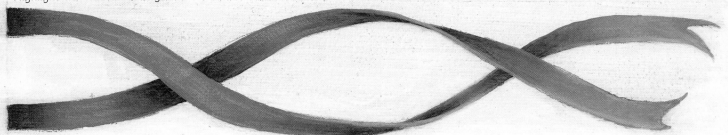

Continued from page 100

Ribbon:

See the Lilies of the Valley Worksheet, Fig. 8.)

1. Undercoat the ribbon with Green Light, using a #8 flat brush. Let dry and cure.
2. Shade the ribbon with a Green Umber float. Let dry.
3. Float accents of Green Dark.
4. Highlight with Ice Green Light. Let dry.
5. *Optional:* If the ribbon is too bold and takes the eye away from the flowers, wash Titanium White over it. Let dry and cure.

FINISHING

1. Spray painting with matte sealer or apply one coat waterbase varnish. ❏

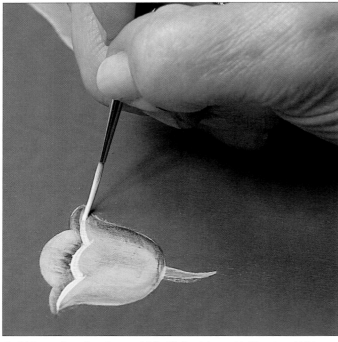

3. Using a liner brush to add "ruffle" edging with Titanium White.

102

Pattern
(actual size)

GERANIUMS PORTRAIT

I often grow geraniums in pots so they can provide moveable accents of color, and I included the pot in this painting.

PALETTE OF COLORS

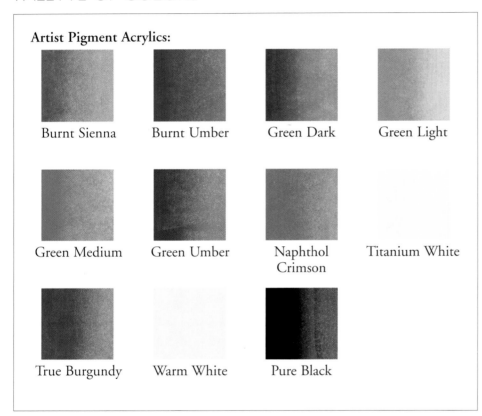

Artist Pigment Acrylics:

Burnt Sienna Burnt Umber Green Dark Green Light

Green Medium Green Umber Naphthol Crimson Titanium White

True Burgundy Warm White Pure Black

SUPPLIES

Painting Surface:
Canvas, 8" x 16"

Brushes:
Flats – #4, #8, #10, #12, #16
Liner – #1
Sponge brushes – 1", 2"

Mediums:
Blending medium

Other Supplies:
Basic supplies listed on page 14.

PREPARATION

1. Lightly sand the canvas with fine grade sandpaper.
2. Wipe any dust away with a tack cloth.
3. Neatly trace and transfer the design using gray transfer paper.

PAINTING THE BACKGROUND

Using a large brush, apply the colors (Green Dark, Green Umber, Burnt Umber, True Burgundy, Naphthol Crimson) around the transferred design. Use the photo as a guide for placement.

PAINTING THE DESIGN

See the Geranium Worksheet.
Flower Pot:
1. Undercoat neatly with Burnt Sienna. Apply a second or even third coat, if needed. Let dry between coats. (Fig. 7)
2. Using white transfer paper, transfer the inner pot lines.
3. Float Burnt Umber shadows. Let dry. (Fig. 8)
4. Apply blending medium. Apply colors (Burnt Umber, Burnt Sienna, Warm White). (Fig. 8)
5. Neatly blend the lower portion of the pot, then the inner portion, then the rim. (Fig. 9)

Continued on page 106

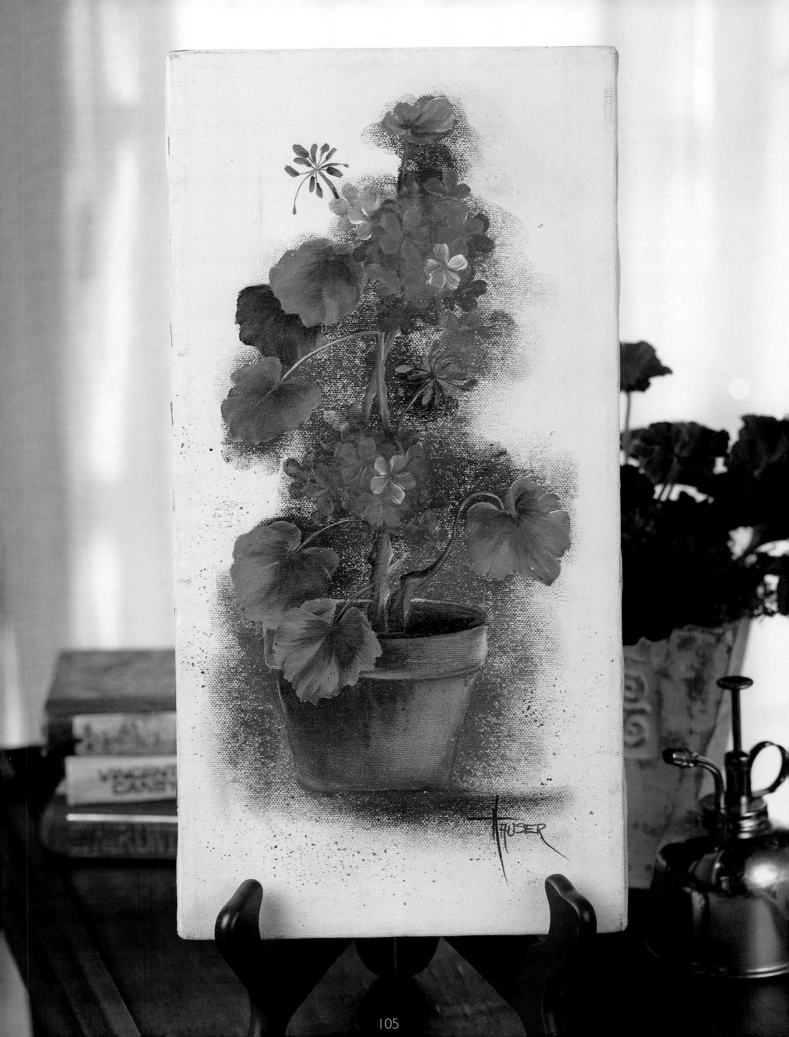

Continued from page 104

Leaves:

1. Undercoat the leaves with Green Medium. Two or three coats will be needed to cover. Let dry. (Fig. 4)
2. Apply a small amount of blending medium, and then apply the colors (Burnt Umber, Green Dark, True Burgundy, Green Light, Green Medium, Warm White). (Fig. 5)
3. Quickly pull the colors from the top toward the bottom, following the natural direction the leaf grows. Wipe the brush frequently; then pull from the bottom to the top. Add more paint, if needed. (Fig. 3)

1. Using a finger to apply blending medium to the cluster before stroking undercoat.

Stems:

1. Paint with Green Medium. (Fig. 5)
2. Shade with Green Umber. (Fig. 6)
3. Highlight with Titanium White. (Fig. 6)

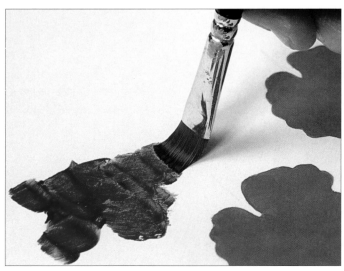

2. Applying the dark mix (True Burgundy + Burnt Sienna).

Geraniums:

1. Mix True Burgundy and Burnt Sienna (1:1) to make a dark red mix. Apply blending medium to the flower cluster, then apply the dark red mix. (Fig. 1)
2. Stroke the shadow or background flowers. (Fig. 1) Make the cluster uneven on the edges – don't let it look like a snowball.
3. While the blending medium and paint are wet, pick up Naphthol Crimson and paint a few medium-value flowers here and there. (Fig. 2)
4. While the clump is wet, mix Naphthol Crimson + Warm White (1:4) to make a light-value color. Add a few light flowers on the cluster. (Fig. 3) Let dry completely.
5. Dot the center of each flower with Yellow Light using your liner brush. Let dry.
6. Add tiny dots of Pure Black at each center.

FINISHING
Apply one coat of finish. ❏

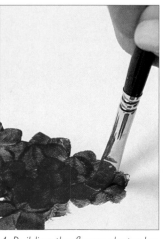

3. Stroking the dark value petals.

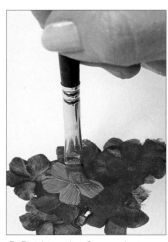

4. Building the flower cluster by stroking medium value petals.

5. Finishing the flower cluster with a few light value flower petals.

Geraniums Worksheet

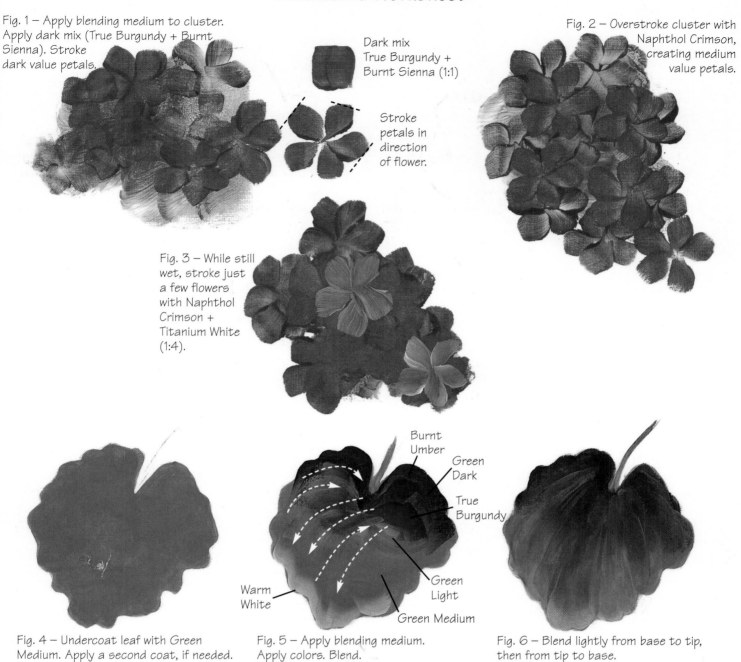

Fig. 1 — Apply blending medium to cluster. Apply dark mix (True Burgundy + Burnt Sienna). Stroke dark value petals.

Dark mix
True Burgundy +
Burnt Sienna (1:1)

Stroke petals in direction of flower.

Fig. 2 — Overstroke cluster with Naphthol Crimson, creating medium value petals.

Fig. 3 — While still wet, stroke just a few flowers with Naphthol Crimson + Titanium White (1:4).

Burnt Umber

Green Dark

True Burgundy

Green Light

Green Medium

Warm White

Fig. 4 — Undercoat leaf with Green Medium. Apply a second coat, if needed.

Fig. 5 — Apply blending medium. Apply colors. Blend.

Fig. 6 — Blend lightly from base to tip, then from tip to base.

Flower Pot
Fig. 7 — Undercoat with Burnt Sienna. Let dry.

Fig. 8 — Float Burnt Umber shadows. Let dry. Apply blending medium. Apply colors.

Fig. 9 — Blend.

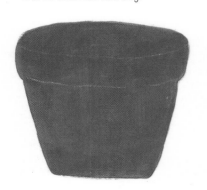

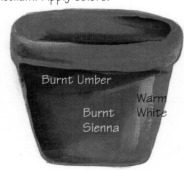

Burnt Umber

Burnt Sienna

Warm White

Pattern

Enlarge pattern @135% for actual size.

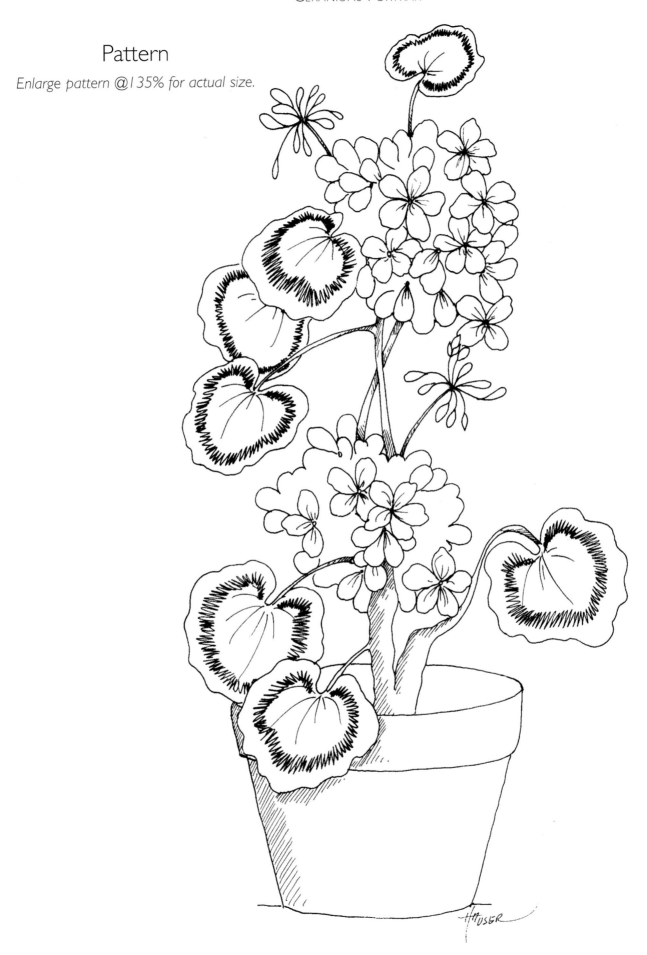

FRAMED GERANIUMS

Here's another example of how to paint geraniums.
The flower petals of these plants have more detail.

Pictured on page 110

PALETTE OF COLORS

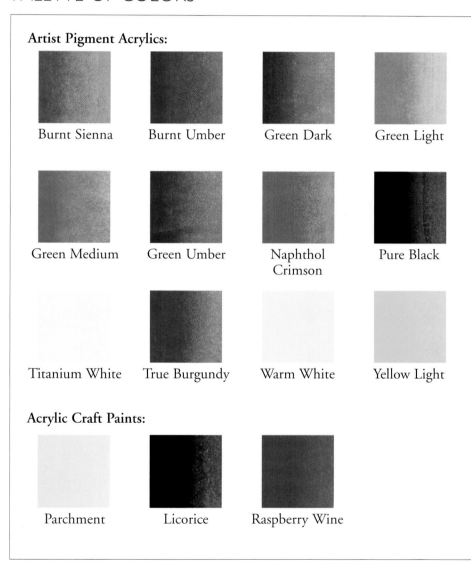

Artist Pigment Acrylics:

Burnt Sienna	Burnt Umber	Green Dark	Green Light
Green Medium	Green Umber	Naphthol Crimson	Pure Black
Titanium White	True Burgundy	Warm White	Yellow Light

Acrylic Craft Paints:

Parchment	Licorice	Raspberry Wine

SUPPLIES

Painting Surface:

Tempered pressed fiberboard
(Masonite®), 5" x 7"

Shadowbox frame, 8" x 10"

Brushes:

Flats – #4, #8, #10, #12, #16

Liner – #1

Sponge brushes – 1", 2"

Mediums:

Blending medium

Other Supplies:

Small 1" thick wooden block

Wood glue

plus the basic supplies listed on page
14.

Instructions begin on page 111.

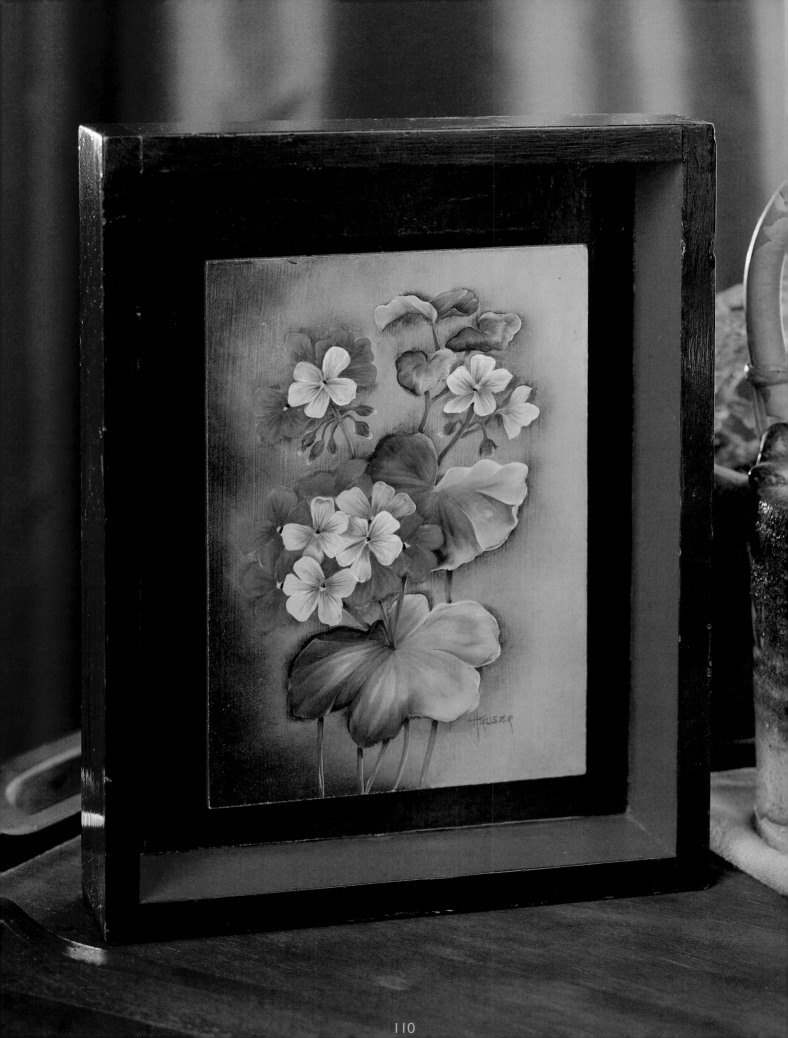

continued from page 109

PREPARATION

Painting Surface:

1. Wipe the surface with a tack cloth.
2. Paint front surface with three coats Parchment. Let the paint dry between each coat.
3. Paint the edge of the fiberboard piece with Raspberry Wine.
4. When third coat is dry, rub with a piece of brown paper bag with no printing on it to smooth the surface.
5. Trace and transfer design to surface.

Frame:

1. Paint the inside surface of the frame sides with Raspberry Wine. Allow to dry. Apply a second and third coat if needed. Let paint dry thoroughly. Mask off with masking tape to protect while painting remainder of frame.
2. Paint all remaining surfaces of frame with Licorice.

PAINTING THE DESIGN

Leaves:

1. Undercoat the leaves with Green Medium. Two or three coats will be needed to cover. Let dry.
2. Apply a small amount of blending medium, and then apply the colors (Burnt Umber, Green Dark, True Burgundy, Green Light, Green Medium, Warm White), with dark colors on the left and lighter colors on the right.
3. Quickly blend the colors, pulling from the base of the leaf to the edge, following the direction the leaf grows. Wipe the brush frequently; then pull from the bottom to the top. Add more paint, if needed.

Stems:

1. Paint with Green Medium.
2. Shade with Green Umber.
3. Highlight with Titanium White.

Geraniums:

1. Mix True Burgundy and Burnt Sienna (1:1) to make a dark red mix. Apply blending medium to the flower cluster, then apply the dark red mix.
2. Stroke the darker petals with Naphthol Crimson. Let dry.
3. Working one petal at a time, shade each petal with the dark mix. Let dry.
4. Using a liner brush, pull lines of thinned True Burgundy on the petals, stroking from the center.
5. Stroke the light value petals with Warm White. Let dry.
6. Shade the edges of a few petals with Green Umber, using the project photo as a guide.
7. Mix Warm White + the dark mix to make a medium value. Shade each light petal with this mix.
8. Add some Naphthol Crimson to the dark mix. Thin with water. Using a liner brush, pull lines using this lightened dark mix on the petals.
9. Dot the center of each flower with Yellow Light. Let dry.
10. Add tiny dots of Pure Black at each center.
11. To turn the edges of some petals, float a scalloped U-stroke with the shading color just below the tip of the petal.

Buds:

1. Undercoat the petals with the medium value shading mix. Let dry.
2. Dab some of the dark mix at the top and some Warm White at the tip. Blend lightly toward the center, allowing some variation for a natural look.
3. Paint the calyx with Green Medium.
4. Shade calyx with Green Umber.
5. Highlight calyx with Titanium White. Let dry and cure.

FINISHING

1. Apply three coats of high gloss varnish to painted piece and frame.
2. Glue wooden block to the center back of painted panel. Let dry. Then glue other side of wooden block to the center back panel of frame. ❏

Framed Geraniums Pattern

(actual size)

Circle of Daisies Pattern

(actual size)

Instructions begin on page 124.

Circle of Roses & Ribbons

(actual size)

Instructions begin on page 120.

Circle of Tulips

(actual size)

Instructions begin on page 114.

CIRCLE OF TULIPS

A design with flowers in a circle is significant to me of everlasting love. Sound silly?
No, I don't think so. This design and the two that follow don't take long to paint
and are just lovely. Metallic acrylic craft paints were used to create the
shimmering dragonfly.

PALETTE OF COLORS

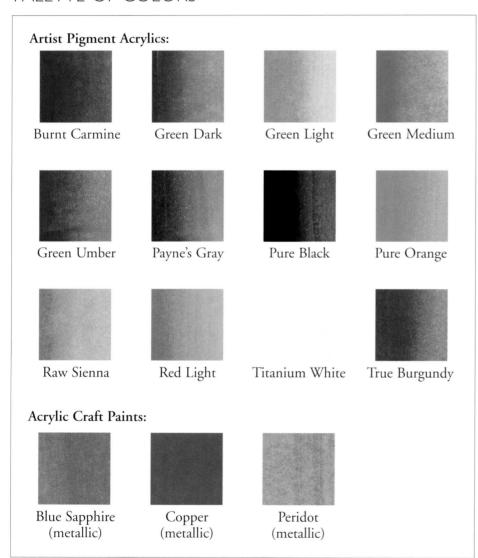

Artist Pigment Acrylics:

Burnt Carmine Green Dark Green Light Green Medium

Green Umber Payne's Gray Pure Black Pure Orange

Raw Sienna Red Light Titanium White True Burgundy

Acrylic Craft Paints:

Blue Sapphire (metallic) Copper (metallic) Peridot (metallic)

SUPPLIES

Painting Surface:

Mat board, 4-1/2" circle

Brushes:

Shaders/Brights: #4, #8, #10, #12, #14

Liner – #1

Mediums:

Blending medium

Glazing medium

Other Supplies:

Matte sealer spray

plus the basic supplies listed on page 14.

PREPARATION

1. Carefully trace the design on tracing paper. See pattern on page 113.
2. Neatly and carefully transfer the design with transfer paper.

Continued on page 116

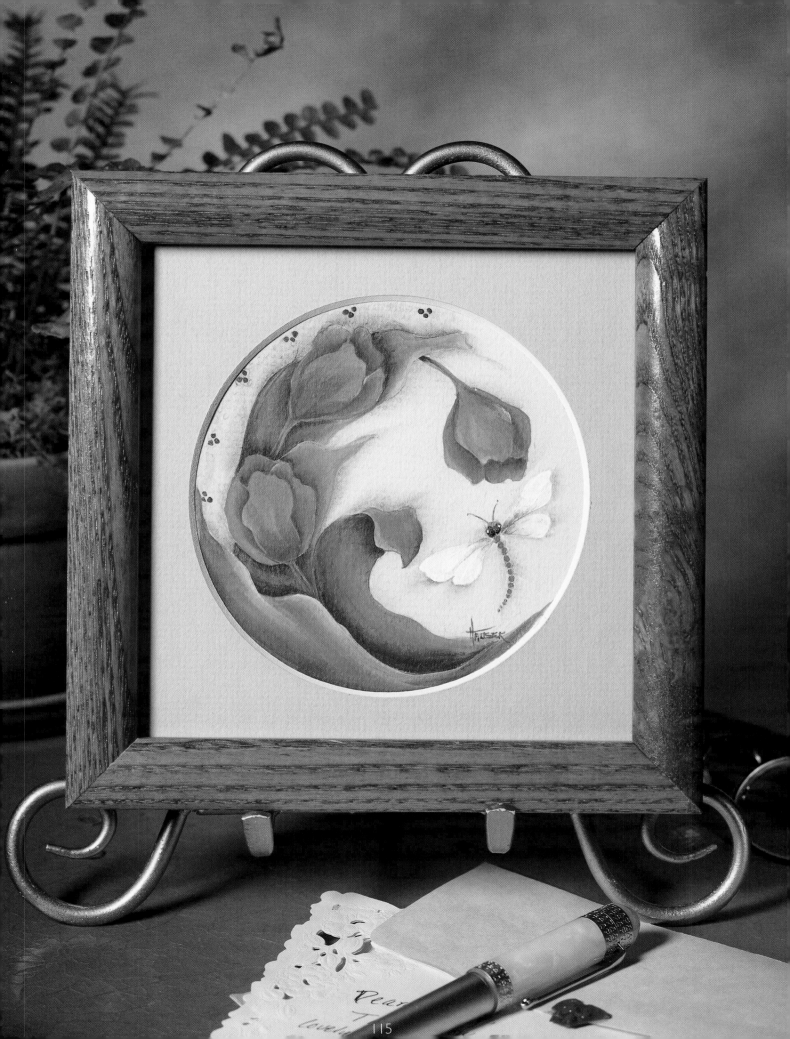

continued from page 114

PAINTING THE BACKGROUND

Use the photo as a guide.

1. Double load a large flat brush with Green Umber and glazing medium (or water). Blend on the palette to soften the color so the color graduates beautifully through the hairs of the brush from dark, to medium, to light.
2. Pat this color around the edge of the entire design, including the dragonfly.

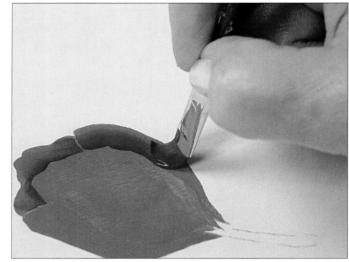

3. Float in the shadows on the petals.

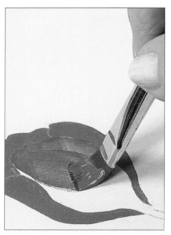

1. Undercoat the tulip with Red Light.

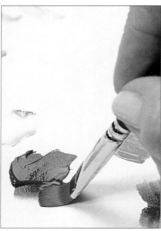

2. Double load brush with Floating Medium + True Burgundy.

PAINTING THE DESIGN

See the Circle of Tulips Worksheet.

Leaves:

Paint the leaves first, working from back to front. The leaves at the back of the design should be darker; those closer to the front should be lighter.

1. Undercoat the leaves with two or three coats Green Medium, allowing the paint to dry between coats. (Fig. 11)
2. Float on Green Dark shadows. Let dry. (Fig. 11)
3. Apply a small amount of blending medium and colors (Green Light, Green Dark, Green medium, Titanium White, Green Umber). (Fig. 12)
4. Wipe the brush and lightly blend, using a light touch.

Tulips:

1. Undercoat the tulips with two or more coats of Red Light. Let dry.

2. Float on True Burgundy shadows. Let dry. (Fig. 6)
3. Starting with the back petal, apply a little blending medium and then the colors (Pure Orange, True Burgundy + Burnt Carmine (1:1)). Wipe the brush and blend. Paint the two side petals, using the same colors and technique.
4. Apply blending medium and colors to the front petal. Begin with Titanium White, then a little Pure Orange around the Titanium White, then a little Red Light around the Pure Orange. Blend. (Fig. 9)
5. Wipe the brush. Double load with blending medium and the True Burgundy + Burnt Carmine mix. Apply this to the base of the front petal. Wipe the brush and blend lightly.
6. Accent the edges of the front petal with S-strokes.

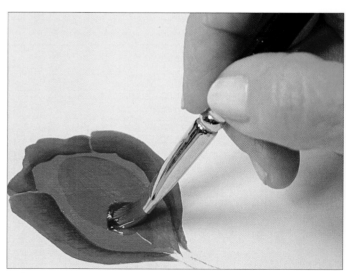

4. Apply blending gel to front petals.

Stems:

1. Paint the stem Green Medium. (Fig. 8)
2. Shade with Green Umber.
3. Highlight with Warm White. Let a little of the petal color blend into the green stem and a little of the green stem blend into the base of the flower. (Figs. 9 and 10)

6. Blend colors together with the dirty dry brush.

7. Side load a little while on the same dirty brush.

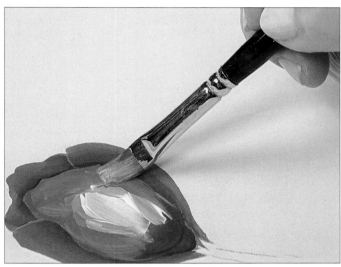

5. Apply three colors to front petal as shown on worksheet.

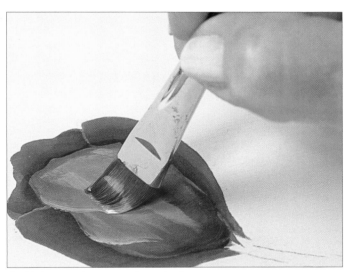

8. Make s-strokes around petal edge.

Dragonfly:

1. Undercoat the wings with Titanium White. Let dry. (Fig. 2)
2. Apply blending medium. Reapply Titanium White. Double load the brush with Titanium White and just a touch of Payne's Gray. Shade the wings. (Fig. 2)
3. Paint the head with Copper. (Fig. 3)
4. Thin Peridot to the consistency of ink. Paint a series of graduated dots for the body. (Fig. 3)
5. Shade the body dots with just a touch of Copper. (Fig. 4)
6. Paint the eyes with Blue Sapphire. Dot the pupils with Pure Black. Highlight with Titanium White. (Fig. 4)
7. Paint antennae with thinned Pure Black. (Fig. 4) Allow the paint to dry and cure.

FINISHING

Spray with matte sealer. ❏

Circle of Tulips Worksheet

Fig. 1 – Paint the design from back to front. This illustration shows the shading around the elements of the design.

Dragonfly
Fig. 2 – Apply blending medium. Paint wings with Titanium White. Shade with a touch of Payne's Gray.

Fig. 3 – Paint head with Copper and body with thinned Peridot.

Fig. 4 – Shade body with Copper. Paint eyes with Blue Sapphire. Add dots of Pure Black. Highlight with Titanium White. Paint antennae with thinned Pure Black.

Circle of Tulips Worksheet

Fig. 5 – The tulip shape.

Fig. 6 – Undercoat with two or more coats Red Light. Let dry. Float on True Burgundy shadows. Let dry.

Fig. 7 – Apply blending medium and colors to back petal.

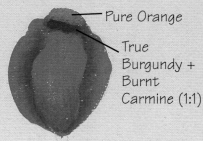

Pure Orange

True Burgundy + Burnt Carmine (1:1)

Fig. 8 – Blend. Apply the same colors to the side petals. Blend.

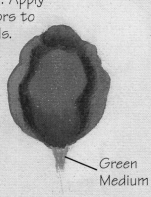

Green Medium

Fig. 9 – Apply colors to front petal.

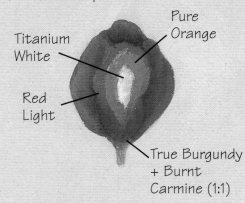

Titanium White

Pure Orange

Red Light

True Burgundy + Burnt Carmine (1:1)

Fig. 10 – Pat and blend. Add S-strokes around the edge.

Turned Leaves

Fig. 11 – Undercoat with Green Medium. Let dry. Float Green dark shadows. Let dry.

Fig. 12 – Apply blending medium. Apply colors.

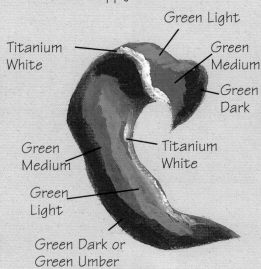

Titanium White

Green Light

Green Medium

Green Dark

Green Medium

Titanium White

Green Light

Green Dark or Green Umber

Fig. 13 – Carefully blend.

CIRCLE OF ROSES & RIBBON

The combination of roses and ribbons is reminiscent of a bridal bouquet.
The white-winged butterfly is a lovely addition.

PALETTE OF COLORS

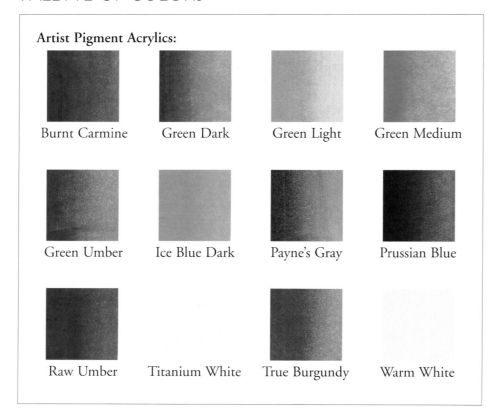

Artist Pigment Acrylics:

Burnt Carmine

Green Dark

Green Light

Green Medium

Green Umber

Ice Blue Dark

Payne's Gray

Prussian Blue

Raw Umber

Titanium White

True Burgundy

Warm White

SUPPLIES

Painting Surface:
Mat board, 6-1/2" circle

Brushes:
Flats – #2, #8, #10, #12, #14
Liner – #1

Mediums:
Blending medium
Glazing medium

Other Supplies:
Matte sealer spray
plus the basic Supplies listed on
 page 14.

Instructions begin on page 122.

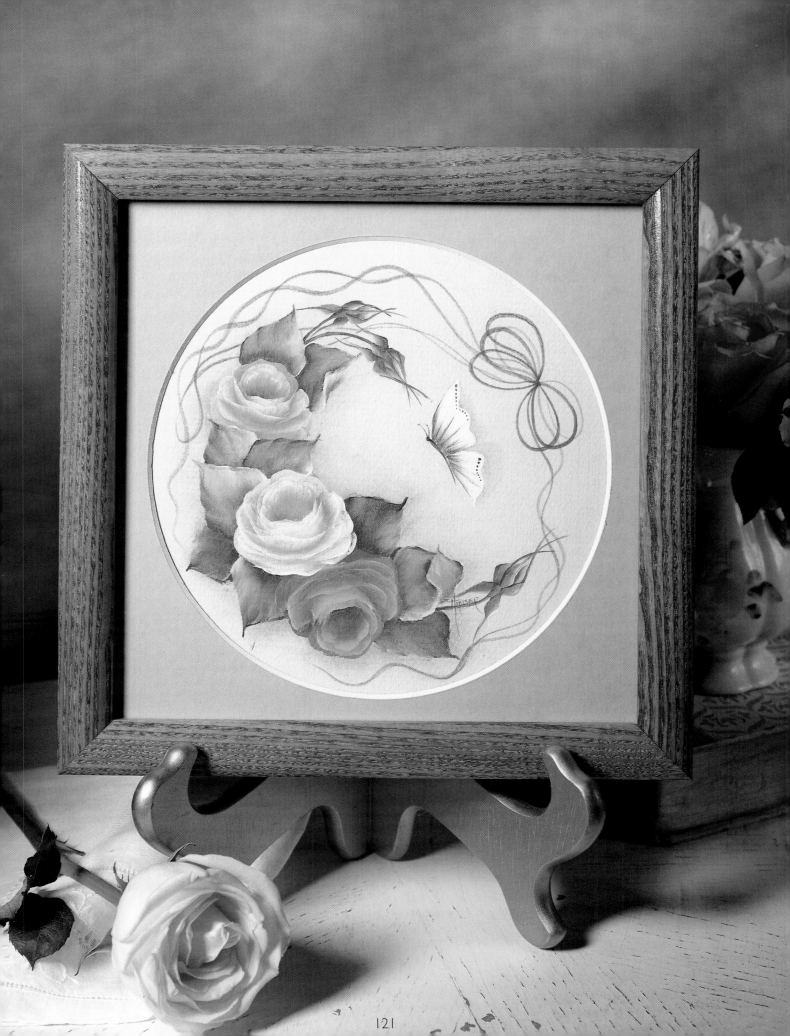

continued from page 120

PAINT THE DESIGN

Background:

1. Trace the design. See pattern on page 113. Transfer neatly and carefully.
2. Load a large flat brush with Payne's Gray and glazing medium or water. Blend on the palette to soften the color. (Not much color is used.) Float around the design. Add touches of True Burgundy here and there. Use the photo as a guide for placement.

Leaves & Roses:

Paint the leaves and roses, following the instructions for the Roses Portrait. Also see the Rose Worksheet and the photo series with the Roses Portrait instructions.

Ribbon:

Create the ribbon with a liner brush and very thin paint. When I teach my seminars, I say, "Liner," and my students say, "THIN!" This means to thin the paint to the consistency of ink. For good results, be sure the brush is good and full of paint. See the Ladybug & Butterfly Worksheet.

1. Mix Prussian Blue + a tiny touch of Titanium White to make a blue mix. Thin the paint.
2. Starting with a dot of color (Fig. 7), form the loops coming from the dot on both the left and the right side. (Fig. 8)
3. Let the ribbon streamers flow. (Fig. 9) Pull the brush slowly with the handle pointing straight up toward the ceiling.
4. Add more Titanium White to the blue mix. Paint more loops and streamers. (Fig. 9)

Butterfly:

See the Ladybug & Butterfly Worksheet.

1. Undercoat the butterfly wings neatly and carefully with Titanium White. Two or three coats will be needed to cover. Let dry between coats. (Fig. 4)
2. Shade with a float of Payne's Gray – use just a little bit of paint. Let dry. (Fig. 4)
3. Apply a little blending medium and reapply the colors. This time use as large a flat brush as possible and blend the Payne's Gray out into the wings. (Fig. 5)
4. Add dots of thinned Payne's Gray to the wings and paint the body. Let dry. (Fig. 6)

FINISHING

Spray with matte sealer. ❏

Pattern on page 113

Ladybug & Butterfly Worksheet

Ladybug

Fig. 1 – Undercoat with Titanium White. Apply Red Light. Let dry between coats. Float on True Burgundy. Let dry.

Pure Black

Fig. 2 – Apply blending medium. Apply colors.

Medium Yellow

Pure Orange

Red Light

True Burgundy

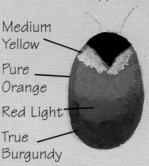

Fig. 3 – Blend. Add Black dots and antennae with thinned paint.

HAUSER

Butterfly

Fig. 4 – Undercoat wings with Titanium White. Let dry. Shade with floats of Payne's Gray.

Fig. 5 – Apply blending medium and re-apply colors. Carefully blend the Payne's Gray out on the wings.

Fig. 6 – Add dots to wings with thinned Payne's Gray. Paint body and antennae.

Payne's Gray

Ribbon

Fig. 7 – Fill a #1 liner with thinned Prussian Blue + Titanium White. Make a dot to begin forming a bow.

Fig. 8 – Paint the loops.

Fig. 9 – Add more Titanium White to the blue mix. Paint more loops and streamers.

CIRCLE OF DAISIES

This small painting of daisies is accented with a bright red ladybug.

PALETTE OF COLORS

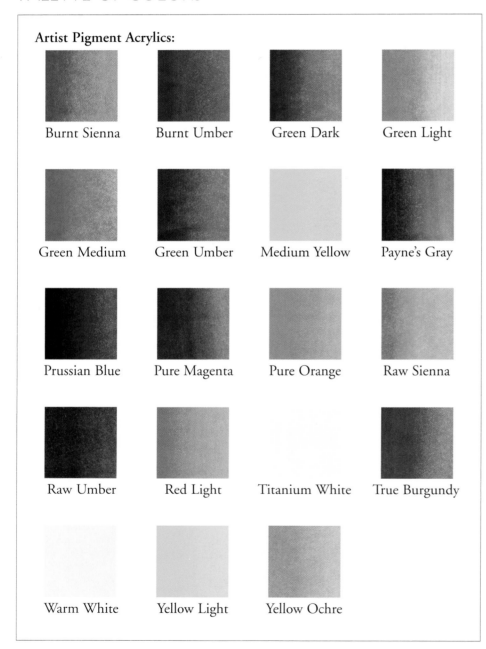

Artist Pigment Acrylics:

Burnt Sienna · Burnt Umber · Green Dark · Green Light

Green Medium · Green Umber · Medium Yellow · Payne's Gray

Prussian Blue · Pure Magenta · Pure Orange · Raw Sienna

Raw Umber · Red Light · Titanium White · True Burgundy

Warm White · Yellow Light · Yellow Ochre

SUPPLIES

Painting Surface:

Mat board, 3-1/2" circle

Brushes:

Shaders/Brights (flat) – #2, #4, #8, #10, #12, #14, #16

Liner – #1

Mediums:

Blending medium

Glazing medium

Other Supplies:

Basic supplies listed on page 14.

PAINT THE DESIGN

Background:

1. Trace and carefully transfer the design. See pattern on page 112.
2. Load a large flat brush double loaded with Payne's Gray and glazing medium or water. Blend on the palette to soften the color, then go around the outside edge of the design. See the project photo for color placement.

Continued on page 126

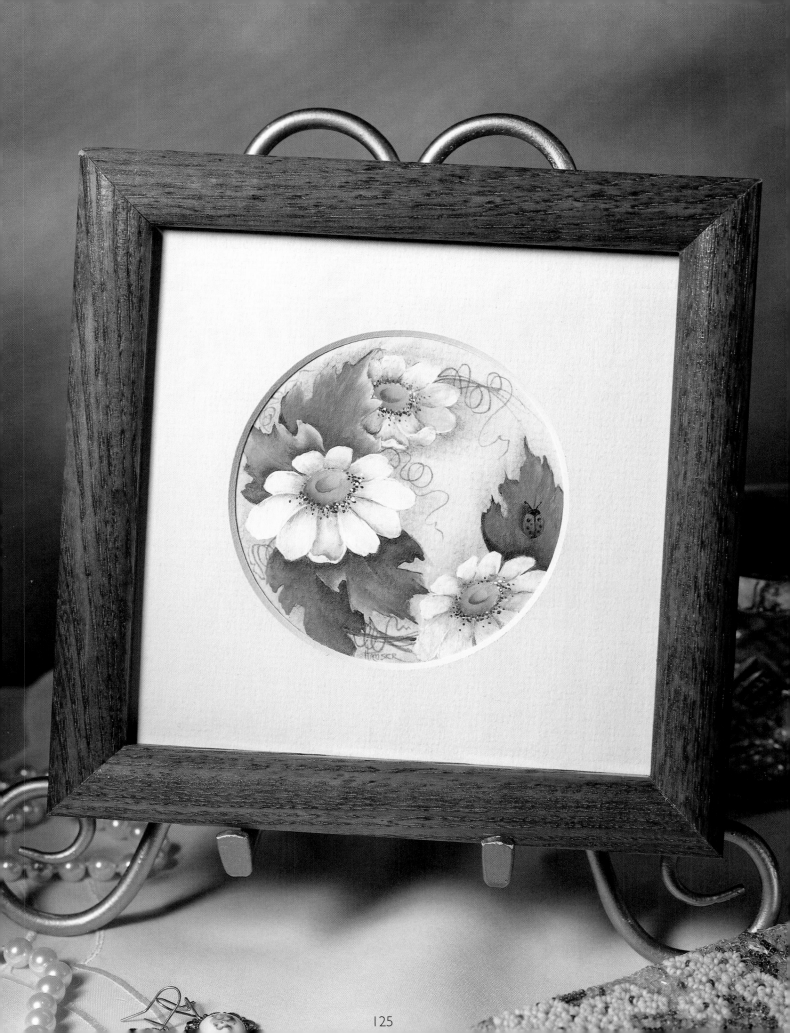

continued from page 124

Leaves & Daisies:
Paint the leaves and daisies, following the instructions for the Spring Surprise project. Also see the Spring Surprise Worksheet and the photo series that accompanies the Spring Surprise project.

Ladybug:
See the Ladybug & Butterfly Worksheet.
1. Undercoat the ladybug with two or more coats Titanium White. Let dry.
2. Paint the body with two or more coats of Red Light. Let dry between coats. (Fig. 1)
3. Paint the head with Pure Black. Let dry. (Fig. 1)
4. Float True Burgundy along the bottom of the ladybug. (Fig. 1)
5. Apply a little blending medium and colors (True Burgundy, Red Light, Pure Orange, and Medium Yellow). (Fig. 2) Wipe the brush and lightly blend where the colors meet each other.
6. Using your liner brush and thinned Pure Black, apply the line work and dots. (Fig. 3)

Curlicues:
Create the curlicues with a liner brush and very thin paint. For good results, be sure the brush is good and full of paint.
Thin Green Umber to the consistency of ink. Load the #1 liner brush. Paint the curlicues, pulling the brush slowly with the handle pointing straight up toward the ceiling. Let dry and cure.

FINISHING
Spray with matte sealer. ❏

Metric Conversion Chart

Inches to Millimeters and Centimeters

Inches	MM	CM	Inches	MM	CM
1/8	3	.3	2	51	5.1
1/4	6	.6	3	76	7.6
3/8	10	1.0	4	102	10.2
1/2	13	1.3	5	127	12.7
5/8	16	1.6	6	152	15.2
3/4	19	1.9	7	178	17.8
7/8	22	2.2	8	203	20.3
1	25	2.5	9	229	22.9
1-1/4	32	3.2	10	254	25.4
1-1/2	38	3.8	11	279	27.9
1-3/4	44	4.4	12	305	30.5

Yards to Meters

Yards	Meters
1/8	.11
1/4	.23
3/8	.34
1/2	.46
5/8	.57
3/4	.69
7/8	.80
1	.91
2	1.83
3	2.74
4	3.66
5	4.57
6	5.49
7	6.40
8	7.32
9	8.23
10	9.14

Index

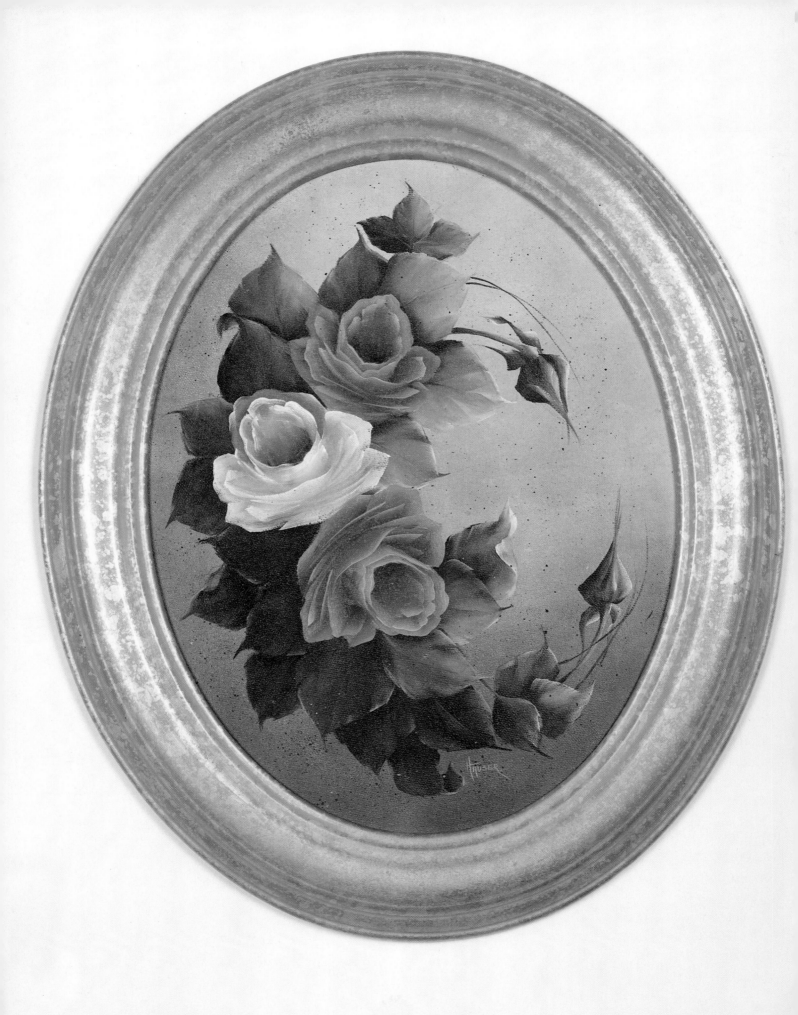